BLACK AMERICA SERIES
SUFFOLK

On the Front Cover: The wedding of Helen Estes and Percy Baker in the late 1930s is pictured here. It was one of many family and social gatherings in Suffolk's black community. (Courtesy Portsmouth Public Library.)

On the Back Cover: Workers and patrons are shown in the Silver Slipper Restaurant on East Washington Street.

BLACK AMERICA SERIES

SUFFOLK

Annette Montgomery

Copyright © 2005 by Annette Montgomery
ISBN 978-0-7385-4177-8

Published by Arcadia Publishing
Charleston, South Carolina

Printed in the United States of America

Library of Congress Catalog Card Number: 2005926984

For all general information contact Arcadia Publishing at:
Telephone 843-853-2070
Fax 843-853-0044
E-mail sales@arcadiapublishing.com
For customer service and orders:
Toll-Free 1-888-313-2665

Visit us on the Internet at www.arcadiapublishing.com

Contents

Acknowledgments 6

Introduction 7

1. Our Roots 11

2. School Days 41

3. Worship and Praise 57

4. Businesses, Professions, and Labor 67

5. Social Organizations and Events 81

6. Health and Medical Care 101

7. Notable People 113

8. Separate and Unequal 123

Endnotes 128

ACKNOWLEDGMENTS

I thank my Lord and Savior, Jesus Christ, for His abundant blessings. For without Him, this project would not have been possible. I thank my mother, Ms. Edna M. Montgomery, and sister, Carol J. Montgomery, who have always supported me in every endeavor.

I would like to thank the following people for their assistance and hospitality during this project: Mrs. Madelaine Wilson, Rev. Clarence J. Word, Mrs. Katie L. Bass, Mr. Jessie Trent, Mr. Harvey Diggs Jr., Mrs. Flora W. Chase, Mrs. Ruby H. Walden, Mrs. Mary A. Davis, Mr. Robert Kelley, Mr. Luther W. Milteer Jr., Mr. John Riddick, Mrs. Sandra Lowe, Mrs. Renee R. Jackson, Mrs. Bernice B. Maloney, Mrs. Elaine Estes, Dr. Donna A. Sullivan Harper, Dr. Bernard Glover, Mr. Ross Boone, Mrs. Jacqueline Miller, Dr. Floyd Miller, Ms. Mary Hill, Mrs. Doris Gordon, Mr. Clarence King, Mr. James Beale, Mr. Rawley Lewter, Ms. Sandra Knight, Mrs. Dorothea Ricks, Mrs. Barbara Gates, Mrs. Katie Knight, Mr. Therbia Parker, Mrs. Hilda Abram, Rev. Robert Hobbs, Dr. and Mrs. Melvin Boone, Mr. Warren Milteer Jr., Mrs. Doretha Milteer, Rev. Jarvis Jones, Mrs. Dorothy Demiel, Mrs. Najawa Spreight, Col. Fred V. Cherry, Ms. Duanne Hoffler, Mr. Raymond Boone, Mrs. Harlena C. MaGee, Mr. Nathaniel Skeeter, Mr. Durmond Skeeter, Mrs. Myrtie Skeeter, Miss Rau'Shanah Skeeter, Mr. Curtis Milteer, Mr. Walter Parker Jr., Miss Lillian Brinkley, Mr. Albert Jones, Miss Alma Ricks, Mrs. Virginia Perry, Mrs. Elizabeth Holland, Dr. Cassandra Newby-Alexander, Ms. Ruth Rose, Mr. Marvin Clemmons, Dr. and Mrs. Edward P. Foreman, and Mrs. Jeanette Mills.

Thanks to Mrs. Edie Carmichael of the history room in the Portsmouth Public Library; Mr. Louis A. Rosenstock of Suffolk's office of the city attorney; Mrs. Brenda Andrews and Mr. Leonard Colvin of the *New Journal and Guide*; Mr. Dale Neighbors of The Library of Virginia; Miss Valencia Moore of the Suffolk Visitors Center; and the Unitarian Universalist Association (UUA).

Special thanks to my sister, Carol, for her never-ending support and assistance; she gives new meaning to the words "big sister," as she cared for me over the years. To my "daughter," Sharlarria Boone Skinner, for her technical support and for being my legs when I needed an extra pair. To my uncle, Thomas Montgomery, who helped raise me; thank you. To my brother, Raymond, much success to you. Thanks to my very dear friends, Cecilia A. Kahan, Sheila Harris, Beverly Ricks-Biggs, Melanie Marion, Shireen Barnes, Sylvonia Lee, Sherlie Boone, Sherry Boone-Thompson, Leandrey Mason, Angela West, Marion Uzzle, and Bradford Smith, for their support and prayers. Thanks also to Allen Settle for his technical expertise and assistance, and to Prof. Colita Nichols Fairfax for being there whenever I had a question. Many thanks to Lucy A. Grant for her assistance and editing expertise, and to Karma Gaines-Ra for her assistance. Many thanks to Steve Craddock for his art and graphic designing, and to Dr. Tommy L. Bogger, whose words "don't talk about it, do it," prompted me to initiate this project. Thanks to Mr. Frederick J. Cox, who always seemed to call at just the right moment to offer words of encouragement.

Lastly, thanks to Ms. Kathryn Korfonta and Arcadia Publishing for their interest in the Black America Series: *Suffolk*.

INTRODUCTION

It is often said that a picture is worth a thousand words. If this is the case, then this pictorial of Suffolk is worth the thousands of words of those African Americans who lived in Suffolk after the Civil War. This book is an attempt to put the names with the faces of those persons who fought, struggled, died, and paved the way for the life that we enjoy today. There are many conveniences that we take for granted today; we need to stop and consider those pioneers who lived right here in Suffolk and were responsible for making Suffolk what it is today. Most of the photographs in this pictorial are from the late 1800s to the late 1960s.

This book is an attempt to pictorially chronicle Suffolk's history in eight segments. "Our Roots" will show some of the pioneers who paved the way in the civil rights struggles. Some of the families are easily recognizable, as they are prominent today.

In the black community, the family stood as the main pillar. As enslaved people, blacks maintained strong family ties, and after emancipation struggled to reunite families disrupted by slavery. This was essential to their source of freedom. After the Civil War, the black family had very little material possessions, so solidarity was significant in family relations. There was an increase in two-parent households and the extended family.

The Suffolk's Skeetertown community, which borders the Dismal Swamp, consists of the Skeeter, Milteer, Faulk, Boone, and Reid families, who are related by blood or marriage. The Skeeter name traces back to the mid-1700s to a white family who intermarried with free blacks.[1] Other families that existed in Suffolk and Nansemond County included the Walden and Holland families from the Holland area, the Roper family, and the Benn family, who migrated from Franklin, Virginia, in the early 1900s.

The photographs in "School Days" will show the early pictures of faculty, staff, and students. Note that photographs show students dressed more formally for school and appearing to be serious about their education. The inability to read and write was not only evidence of previous submissive conditions for former slaves, but also was a hindrance to their prosperity and survival as free people. During Reconstruction, the Freedman's Bureau, missionary societies, and blacks themselves established schools in the South, laying the foundation for public education. Even though their benevolent societies provided funds for black education, it was blacks who took the initiative to purchase land, construct buildings, and raise money to hire teachers. Faced with crowded, ill-furnished, one- and two-room schools, students and teachers made do with the available materials. Their strong desire for an education made the conditions bearable.

Public education in Suffolk began in 1871. It was then that the first school board was formed to provide an education for all students, including those in Nansemond County. There were private and free schools for whites but none for blacks. In 1890, the Reverend William W. Gaines, pastor of the African American First Baptist Church founded the Nansemond Normal and Industrial Institute.[2]

The segment dealing with "Worship and Praise" will show photographs of Suffolk residents and how they used the church for social, civic, and religious activities. For centuries, religion has played an important role in the lives of African Americans, even though the

emergence of the black church had to await the end of slavery. In services ruled by whites, slaves had no voice in church affairs; they were confined to the rear of the sanctuary or balcony, and were viewed as spectators rather than members of the congregation. White parishioners were unwilling to change their policies regarding segregation or to give former slaves significant authority within white churches. Therefore, they welcomed and encouraged blacks' withdrawal from the predominately white congregation. Both blacks and whites agreed, for different reasons of course, to separate churches.

Once established, black churches spread rapidly throughout the South. The Baptist church, the largest religious organization, frequently divided its congregation due to challenges in leadership. The Shoulders Hill Church was organized in 1786 between Portsmouth and Nansemond County. Even though whites owned the church, the original members included both blacks and whites. The area, Shoulders Hill, was named after the owner of the land where the church was built. In 1865, the original house of worship was sold to blacks, and the name was changed to Union Baptist Church. The Reverend Ruben Jones, a white minister who had been the original pastor of Shoulders Hill Church, organized Union Baptist in 1865. He served until Rev. Jordan Thompson, the first African American minister ordained in the county, was called to serve.[3]

Another prominent religious institution was the Belleville Home. Known as a utopia for the needy, it was operated by the Church of God and Saints in Christ. Founded in 1918 by Bishop William Henry Plummer, it was a safe haven for widows, orphans, and the indigent.

"Businesses, Professions, and Labor" will show some of the people and organizations in early Suffolk that were instrumental in changing the Jim Crow laws. In the early 1900s, when Jim Crow laws institutionalized segregation of blacks and whites, most black-owned businesses lost the few white clients they had, and black consumers were deprived of places to buy goods and services. The change caused blacks to rely on trading with each other. There were other African Americans who made a decent living operating businesses such as funeral parlors, restaurants, drug stores, barbershops and beauty salons, and neighborhood and country stores.

The period after World War I was especially tough for blacks because of the Depression. Those who had skills were able to secure jobs in factories or work in positions such as loggers, maids, butlers, chauffeurs, or other trades. They didn't have much choice to work in these positions because of their limited education. Occupations such as mail carriers, elevator operators, waiters, teachers, ministers, janitors, and bus boys were limited and stepping-stones for many who had determination and skill. Economic and social life emerged on East Washington Street and Norfolk Road.[4] The Fairgrounds, as it was called, is best remembered as a vibrant center of the social life of Suffolk's black community as well as the heart of its business establishments.

"Social Organizations and Events" will show how Suffolk wasn't much different than other black communities in America. From the beginning of the 19th century to the mid-20th century, black churches and social organizations were the sole source of community leadership. Over decades, social organizations have provided the African American community with social events, community support, and a sense of belonging.

After the abolishment of slavery, benevolence societies and fraternal orders were established to help provide the basic needs for the adjustment to a life of freedom. Living in rural areas, many families had to rely on the liberality of relatives, neighbors, and the church to meet their needs. Black social organizations in southeast Virginia were strongly committed to serving their own communities. They later provided financial services that were unavailable to blacks at most white-owned financial institutions. When they had problems securing loans, blacks organized building and loan associations to build or purchase homes. Their support of economic development, education, and the church helped to build and strengthen the African American community. The

pictures in this segment will show members at fraternal, sorority, civic, business, and social gatherings.

The segment on "Health and Medical Care" probably is the most compact and complete section because there was only one black hospital in Suffolk. Pictures in this section will show Suffolk Community Hospital, the first black nurse hired by the state of Virginia, the first black husband and wife physicians in Suffolk, and the first black nurse supervisor at Louise Obici Hospital. Also in this section will be photographs of dentists, doctors, and nurses who practiced during segregation.

"Notable People" will show various African Americans of Suffolk origin who made contributions for the whole of Suffolk. Contributions were made by many of them to the Suffolk community, to the state of Virginia, and to the United States. Suffolk was home for a host of African American leaders who not only made a difference, but also did not get all of the recognition that they deserved. This book will highlight individuals whose work helped others to remember that it is possible to make a difference.

"Separate and Unequal" will show the signs and symbols of Suffolk during segregation. Pictures will also show some of those persons who experienced segregation and their visual attempts to combat the issue. After the Civil War, blacks throughout the South organized meetings to demand equality before the law. They wanted the right to vote and equal access to schools, employment, transportation, as well as other public facilities. Blacks demanded recognition of their rights as American citizens. By the 1950s, the Civil Rights Movement had organized, and the struggle to end racial discrimination and segregation began. Boycotts, sit-ins, and strikes were formed to combat this injustice.

I hope this assimilation of photographs will give the reader an appreciation of Suffolk's rich African American heritage. Further, I hope that the readers will be able to identify with some of these photographs and will recognize the need to keep and label their family histories in such a way that their descendants will be eternally remembered.

One
OUR ROOTS

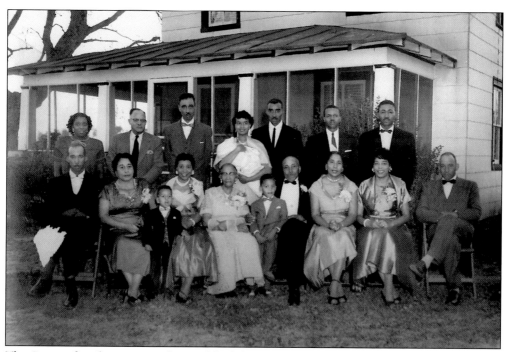

The Owens family was one of many black farming families in Suffolk. In 1957, this family was awarded "Outstanding Farm Families." This award, presented by the state, was designed to recognize one farming family annually. In this photograph, taken October 30, 1954, Mr. Frank and Mrs. Dulah Owens were celebrating their 50th wedding anniversary at their home on Manning Road. Pictured from left to right are (first row) Carlton Owens, Bernyce O. Wynn, Douglas Boone, Ruth O. Jackson, Dulah Luke Owens, Michael Davis, Frank E. Owens, Mary A. O. Davis, Allene O. Cox, and Wayman Owens; (second row) Doris C. Owens, Jack Wynn, Willie Jackson, Ann Boone holding infant Dwayne, Douglas Boone, Benjamin Davis, and Cerbon Cox. (Courtesy Mary A. Davis.)

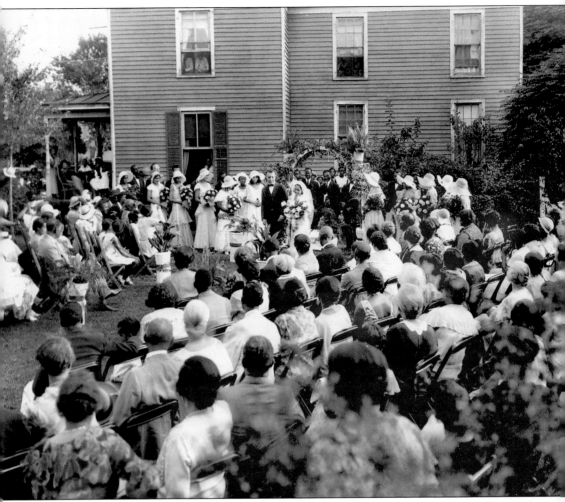

Pictured here in the late 1930s is Miss Helen Estes's marriage to Mr. Percy Baker. Helen Estes was the daughter of James and Mary E. Estes of Wellons Street. Mr. Estes was the first African American mail carrier in Suffolk, and Mrs. Estes was an educator. Both Helen and Percy graduated from the Virginia Normal and Industrial Institute (Virginia State College) in 1927. (Courtesy Portsmouth Public Library.)

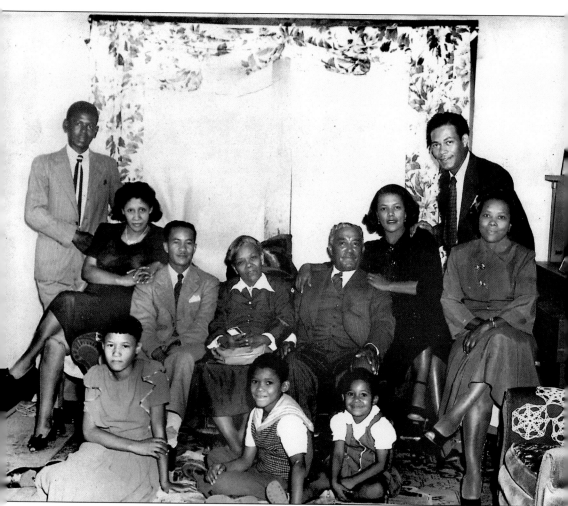

Members of the Lowe family, pictured around 1948, are identified from left to right: (first row) Jean Lowe, Elgin M. Lowe Jr., and Sandra Lowe; (second row) Calvin Fortune (son of Dainer), Mrs. Lois B. Lowe, Mr. Elgin M. Lowe Sr., Mrs. Luzie S. Lowe, Bishop Charles W. Lowe, Mrs. Danier E. Robinson, Mr. Joseph Lowe, and Ms. Iola Branch (cousin). (Courtesy Sandra Lowe.)

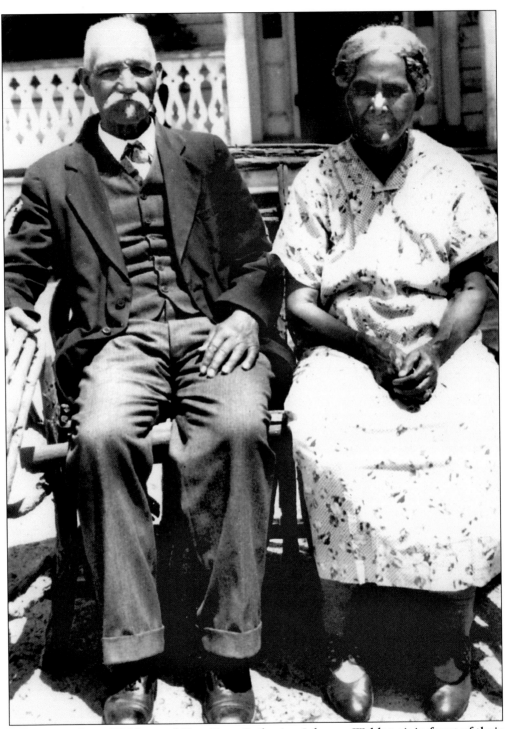

Mr. Titus LeGrant Walden and Mrs. Mary Catherine Johnson Walden sit in front of their Nansemond County home. Together the couple raised 14 children. The National Archives used this 1932 photograph for many exhibits. (Courtesy Flora Walden Chase.)

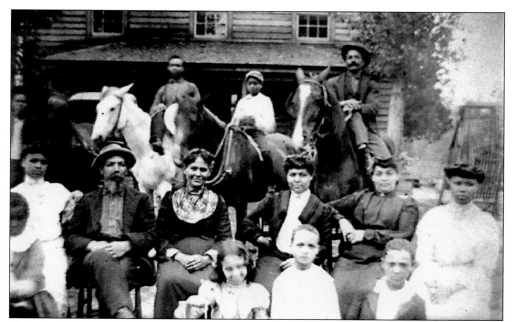

This Titus LeGrant Walden family portrait was made around 1906. Pictured, from left to right, are (first row) Moses Walden, Flossie Walden (Browne), Theophilus Walden, and Floyd Walden; (second row) Mrs. Laura Walden Reid, Mr. Titus LeGrant Walden, Mrs. Mary Catherine J. Walden; Mrs. Lula Walden Hunter, Mrs. Deborah W. Howell (Titus's sister), and Mrs. Essie Walden Boone; (third row) Willis Walden, Obadiah Walden, Squire Walden, and Delaware Howell (Deborah's husband). (Courtesy Flora W. Chase.)

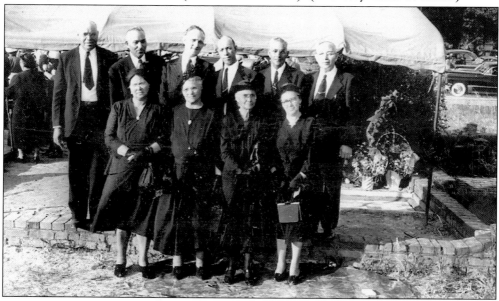

The children of Titus LeGrant Walden are pictured at his funeral in 1950. Pictured from left to right are (first row) Mrs. Essie W. Boone, Mrs. Laura W. Reid, Mrs. Lula W. Hunter, and Mrs. Flossie W. Browne; (second row) Mr. Willis W. Walden, Mr. Moses Walden, Mr. Theophilus Walden, Mr. Floyd Walden, Mr. Squire Walden, and Mr. Obadiah Walden. (Courtesy Ruby H. Walden.)

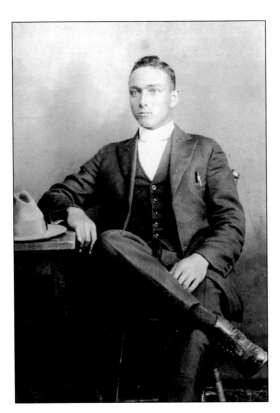

Pictured here is Mr. Theophilus "Bade" Walden, son of Titus and Catherine Walden. (Courtesy Flora W. Chase.)

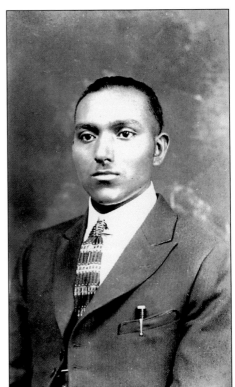

This is a photographs of young Moses G. Walden, son of Titus and Catherine Walden. (Courtesy Flora W. Chase.)

Mr. Floyd E. "Buddie" Walden, son of Titus and Catherine Walden, is shown here as a young man. (Courtesy Flora W. Chase.)

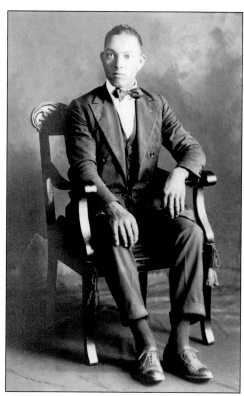

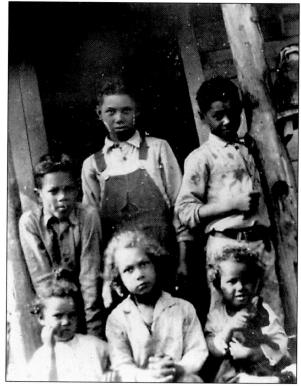

The children of Mr. Willis W. Walden from left to right are (seated) Felecia, Juanita, and Adelaide; (standing) Allison, Frank, and Fletcher. (Courtesy Ruby H. Walden.)

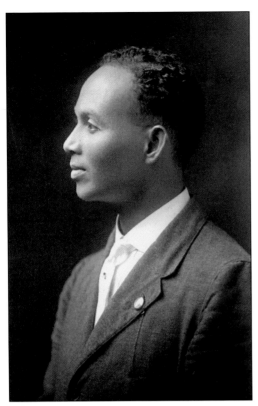

In 1915, Mr. Obadiah Walden purchased a lot for $650 and built a two-story brick building. He and his wife, Coma, and their only child, Flora, lived on the upper level, and the lower level was used as a store. Mr. Walden grew to become a respected businessman, grocer, and butcher in the Holland section of Nansemond County. (Courtesy Flora W. Chase.)

Mrs. Coma Porter Walden, wife of Obadiah, worked alongside her husband minding the store. After their daughter, Flora, finished college, Mrs. Walden went to college and earned a degree in education. (Courtesy Flora W. Chase.)

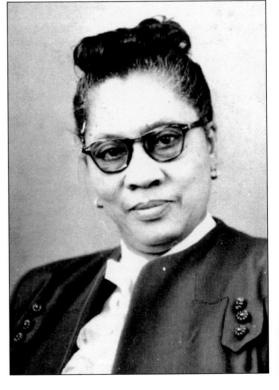

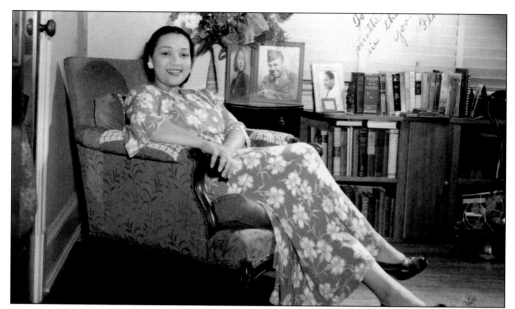

Here is Mrs. Flora Walden Chase, daughter of Obadiah and Coma Walden. After graduating from Thyne Institute and Virginia State College, Mrs. Chase pursued a career in education. She resided in Washington, D.C., (and is pictured in her D.C. apartment) and taught in the area. She retired from the T. C. Williams High School in Alexandria, Virginia. After retiring, Mrs. Chase returned to her native Holland home. Now a widow, she was married to the late jazz pianist, Mr. Tommy Chase. (Courtesy Flora W. Chase.)

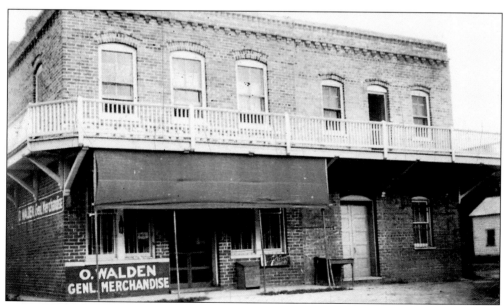

This is a photograph of the Obadiah Walden General Merchandise and the family home. The store flourished for 50 years as Mr. Walden sold everyday goods, groceries, and his specialty for which he became known: fresh beef. People traveled for miles to purchase his meat. He eventually received a certificate to grade beef, and he graded for other butchers who bought and sold cattle in the county. (Courtesy Flora W. Chase.)

Mrs. Laura Walden Reid, daughter of Titus and Mary Walden, is pictured here in 1960. She married Mr. Lonnie L. Reid. (Courtesy Flora W. Chase.)

Mr. Lonnie Livingston Reid and Mrs. Laura Walden Reid are pictured in their home on South Wellons Street in 1948. Mr. Reid, born in 1880, died in 1949. Mrs. Reid was born 1891 and died in 1962. The couple had four children: Lonnie Titus, Mary Edith, Rudolph, and Iva. (Courtesy Donna A. Sullivan Harper.)

Mr. Lonnie L. Reid and his eldest son, Lonnie Titus Reid, are standing beside their home around 1940. (Courtesy Donna A. Sullivan Harper.)

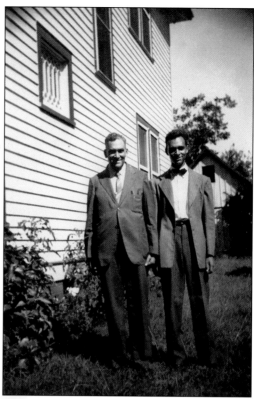

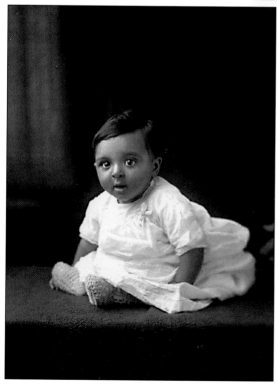

This beautiful infant is Lonnie Titus Reid, born in 1918 to Mr. Lonnie L. and Mrs. Laura W. Reid. (Courtesy Flora W. Chase.)

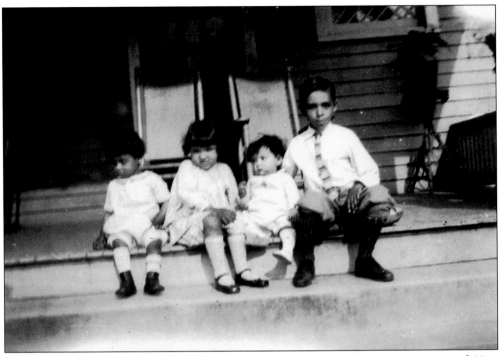

In this picture, taken around 1927, are the young children of Mr. Lonnie L. and Mrs. Laura W. Reid. Pictured from left to right are Rudolph, Mary Edith, Iva Maidie, and Lonnie Titus. (Courtesy Donna A. Sullivan Harper.)

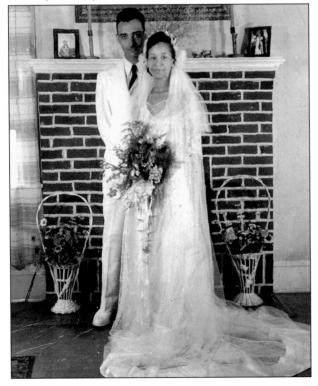

Doctors Lonnie Titus and Margaret Williams Reid pose for their wedding portrait on June 23, 1942. (Courtesy Flora W. Chase.)

Mrs. Mary Edith Reid Gatlin and her husband, Mr. Blass Gatlin, pose on their wedding day. (Courtesy Flora W. Chase.)

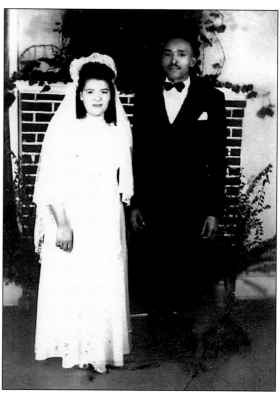

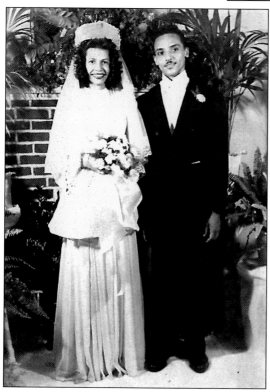

Mr. Rudolph Reid is pictured with his new bride, Elaine. (Courtesy Flora W. Chase.)

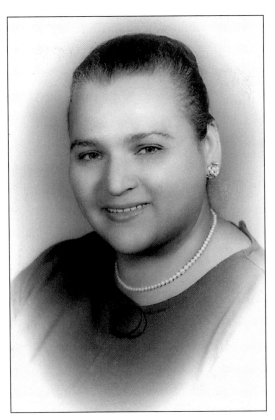

Mrs. Iva Maidie Reid Sullivan was born in 1925 to Lonnie L. and Laura Walden Reid. A graduate of Booker T. Washington High School, she earned both her bachelor's and master's degrees from Hampton Institute. Mrs. Sullivan gave more than 20 years of service to the Suffolk Public School System, where she taught at Booker T. Washington, John F. Kennedy High, and Suffolk High Schools. She retired as a guidance counselor at Suffolk High. She was also a loyal and dedicated member of the First Baptist Church, where she was a member of the Lily of the Valley Club. Mrs. Sullivan passed away in 1986. (Courtesy Flora W. Chase.)

The Sullivan family is pictured in 1975 at Oberlin College in Ohio while attending graduation activities for their daughter, Donna. Pictured from left to right are Mrs. Iva Reid Sullivan, Dr. Edwin Sullivan, and Donna Sullivan. (Courtesy Donna A. Sullivan Harper.)

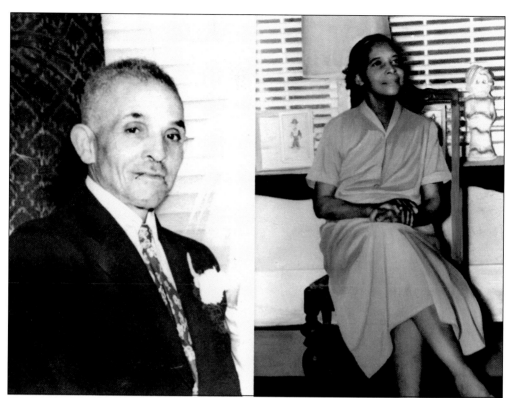

Mr. Mack C. Benn Sr. and Mrs. Mamie Scott Benn, both natives of Southampton County, were married in 1910. In 1925, they moved to Nansemond County. Mr. Benn was the son of Wesley Wellington Benn and Ann S. Benn. Mrs. Mamie S. Benn was the daughter of Samuel and Hattie Scott. Mack Benn Sr. was a farmer until 1942 when he went to work at the naval base in Norfolk during World War II. Mrs. Benn was a housewife. Together they had eight children, one of whom died of pneumonia at the age of one year old. (Courtesy Bernice B. Maloney.)

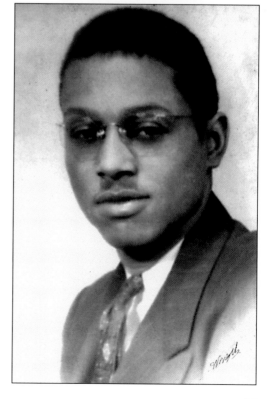

Mr. Herman T. Benn, the eldest child of Mack and Mamie Benn Sr., is a graduate of Virginia State College and Terrell Law School in Washington, D.C. He was an educator before he went on to become a lawyer and federal law judge. (Courtesy Bernice B. Maloney.)

Mrs. Wanetah Benn Davis, a graduate of Virginia State College, taught school for 40 years. (Courtesy Bernice B. Maloney.)

Mr. Winifred T. Benn, a graduate of Bluefield State College in West Virginia, taught in the Suffolk Public School System. (Courtesy Bernice B. Maloney.)

Mr. Wesley W. Benn, who graduated from East Suffolk High School during World War II, became an instructor of heavy driving equipment at the naval base in Norfolk. (Courtesy Bernice B. Maloney.)

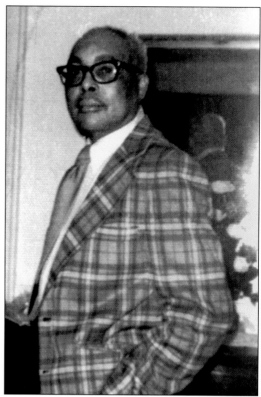

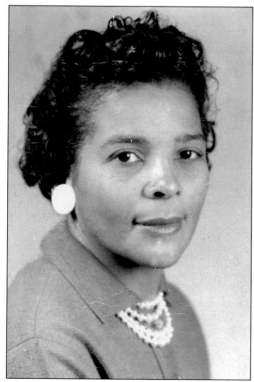

Mrs. Dorothy Benn Armistead is a graduate of Elizabeth City State College and taught in the Franklin Public School System for more than 35 years. (Courtesy Bernice B. Maloney.)

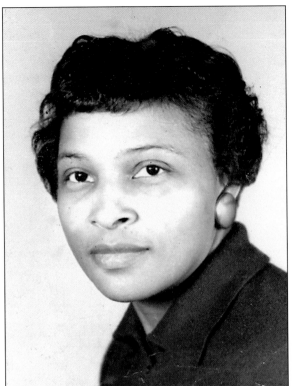

Mrs. Bernice Benn Maloney is a graduate of Virginia State College and Indiana University. She taught school and served as a guidance counselor in the Suffolk Public School System for more than 38 years. (Courtesy Bernice B. Maloney.)

Mack C. Benn Jr., a graduate of Bluefield State College and Indiana University, taught in the Suffolk Public School System and served in many other positions before he retired. (Courtesy Bernice B. Maloney.)

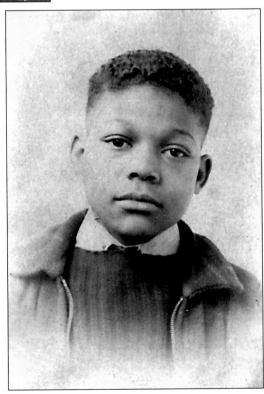

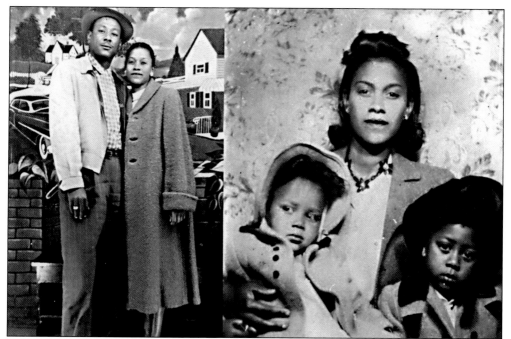

Mr. John Brinkley and Mrs. Ella Brinkley, posing in this 1940s photograph while attending the Tidewater Fair, were residents of the Skeetertown community. Pictured to the right is Mrs. Ella Brinkley with daughters Lillian (left) and Lorraine. (Courtesy Lillian Brinkley.)

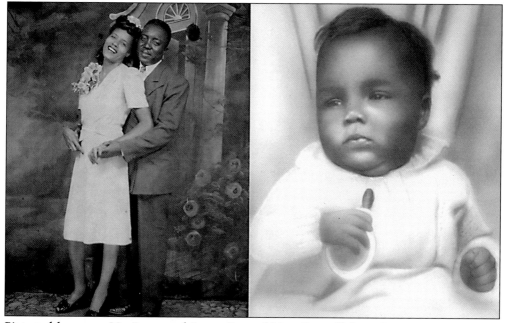

Pictured here are Mr. Raymond Jones Sr. and Mrs. Burnell Scott Jones. Mr. Jones was the child of Ms. Viola Morgan, and Mrs. James Burnell Scott Jones was the daughter of Linwood and Sylvania Brinkley Scott of the South Suffolk area. They had one child, Raymond Jr. (pictured right).

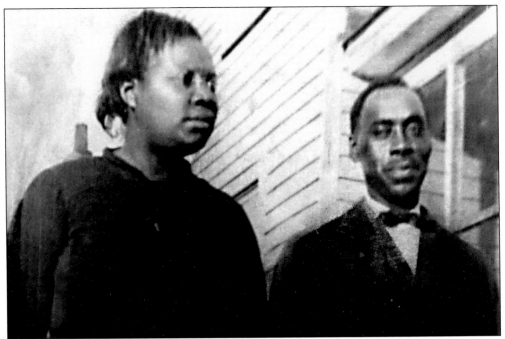

Mrs. Rebecca Riddick and Mr. Moses Riddick worked as laborers in Nansemond County. Mr. Riddick was employed at Crocker's Sawmill on Hosier Road, and Mrs. Riddick worked at the Farmer's Basket factory. They had two sons, Moses Jr. and John. (Courtesy John Riddick.)

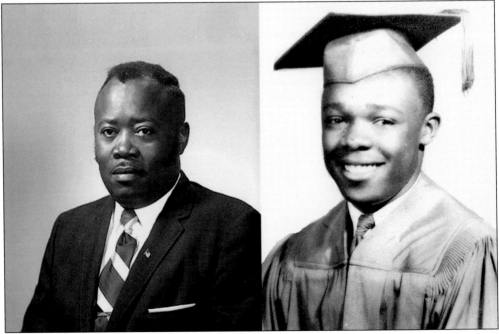

Moses Riddick Jr. (left) is pictured in 1969 when he ran as a candidate for lieutenant government of Virginia. John Riddick is shown in this 1946 graduation portrait from Booker T. Washington High School. (Courtesy John Riddick.)

This is a picture of the Hughes family who migrated from Georgia. From left to right are (first row) Lille, Harry, and Laura; (second row) Mrs. Emma Hughes, Fred, and Mr. Julius Hughes. (Courtesy Renee Roper Jackson.)

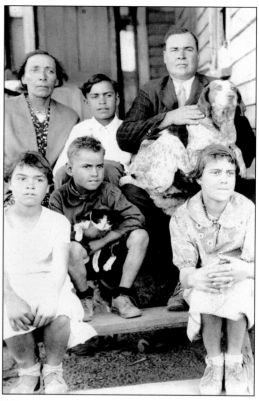

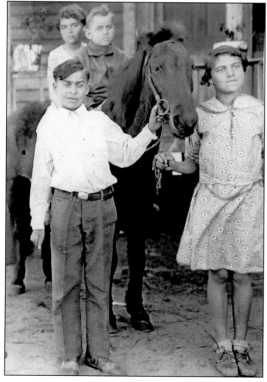

The Hughes children take turns riding their horse. Fred and Laura are pulling the horse, while Lillie and Harry take their turn. (Courtesy Renee Roper Jackson.)

The Walker family includes Mr. William Henry Walker Sr. with son Shavor, and wife Mrs. Braddie Walker holding grand-daughter Barbara A. Roper. Standing from left to right are the Walkers sons, Aquilla and Joel, who is holding grandson Kennard Roper III. (Courtesy Renee Roper Jackson.)

The children of William Henry and Braddie Walker shown from left to right are Porter, Joel, Myrtis, Shavor, and Emma Ruth. Standing in back is friend Milford Graves. (Courtesy Renee Roper Jackson.)

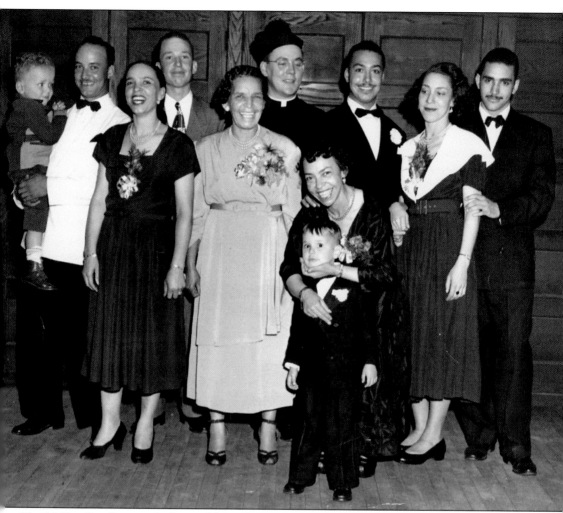

The Walker family attends the wedding of Shavor. Pictured from left to right are Mr. Porter Walker holding Frank, Mrs. Myrtis Walker Roper, Mr. Aquilla Walker, Mrs. Braddie Walker, unidentified priest, Mrs. Addie Louise Walker Thomas hugging Ditmar Walker, Shavor Walker, Emma Ruth Walker, and Mr. Joel Walker. (Courtesy Renee Roper Jackson.)

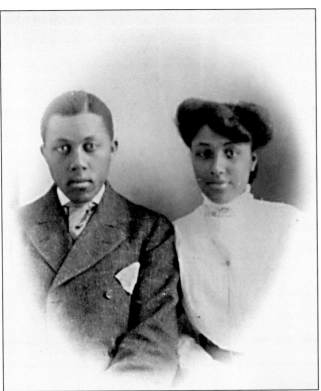

Pictured here are Mr. Kennard Scotwood Roper and Mrs. Bessie Smith Roper. (Courtesy Renee Roper Jackson.)

Kennard Roper II was the son of Kennard and Bessie S. Roper. (Courtesy Renee Roper Jackson.)

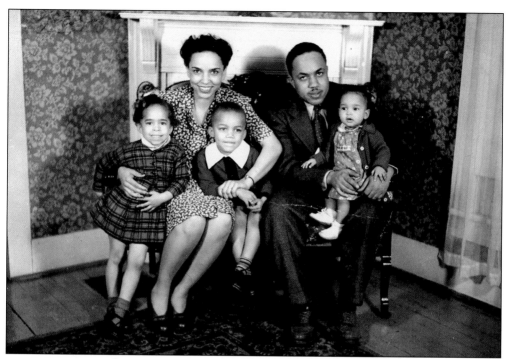

Mr. Kennard S. Roper and Mrs. Myrtis Walker Roper pose for a family photograph with their children. Listed from left to right are Barbara Ann, Kennard S. III, and Nikki Jill. (Courtesy Renee Roper Jackson.)

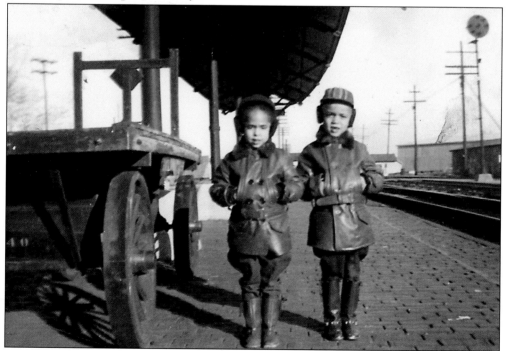

Pictured here are Barbara (left) and Kennard III at the train station in Suffolk. (Courtesy Renee Roper Jackson.)

Mr. James (Jimmy) S. Langston of Holland is featured in this photograph. (Courtesy Ruby H. Walden.)

Mrs. Primmie Langston, wife of James Langston, poses in this image. (Courtesy Ruby H. Walden.)

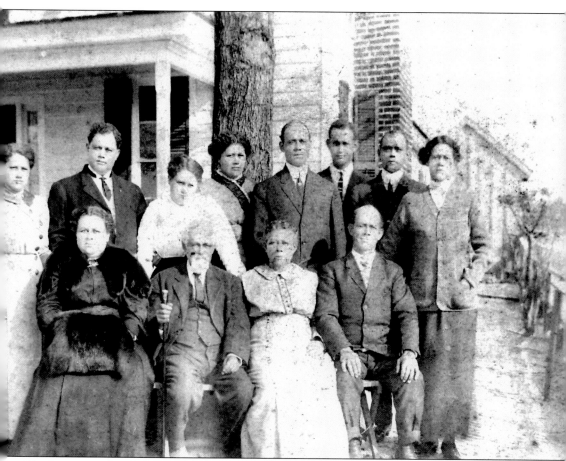

The Langston family is pictured in front of their Holland home. Pictured from left to right are (first row) Maggie, Mr. James S. Langston, Mrs. Primmie Langston, and Buddy; (second row) Pearl, George, Primmie, Alma, Alexander, James Jr., Alphozo, and Anna. (Courtesy Ruby H. Walden.)

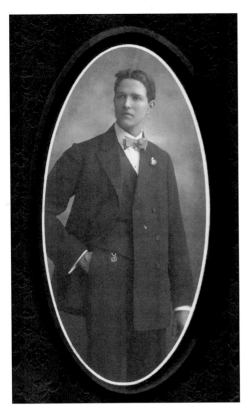

Mr. Axium J. Holland was a prominent farmer and carpenter in Holland. He built his family's home and donated the land to build the Silver Springs Elementary School. (Courtesy Ruby H. Walden.)

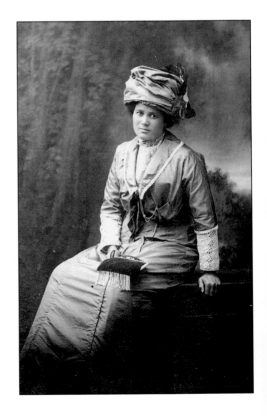

Mrs. Pearl Langston Holland, daughter of James and Primmie Langston, married Axium J. Holland. (Courtesy Ruby H. Walden.)

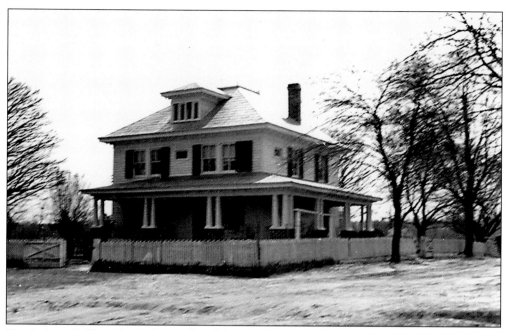

Mr. Axium Holland built the Holland family home. (Courtesy Ruby H. Walden.)

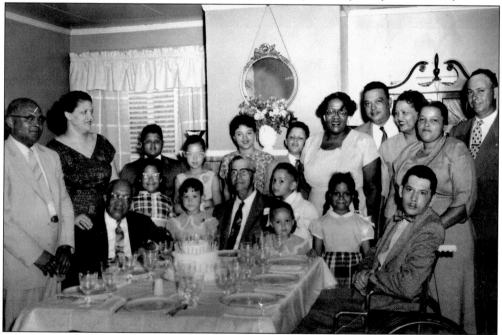

Mr. Axium J. Holland is seated in the center of his family at his 75th birthday celebration. From left to right are (first row) Dr. Frank N. Harris, Jackie Holland, Sandra Walden, Mr. Axium Holland, Pearl Walden, Olin Walden, Frankie Holland, and Mr. Reginald Holland; (second row) Dr. Walter P. Richardson, Mrs. Thelma Holland Richardson, Preston Richardson, Janice Walden, Joyce Richardson, Robert Holland, Dr. Ernell Harris-Holland, Mr. Roswell Holland, Mrs. Ruby Holland Walden, Mrs. Maggie Holland, and Mr. Frank Walden. (Courtesy Ruby H. Walden.)

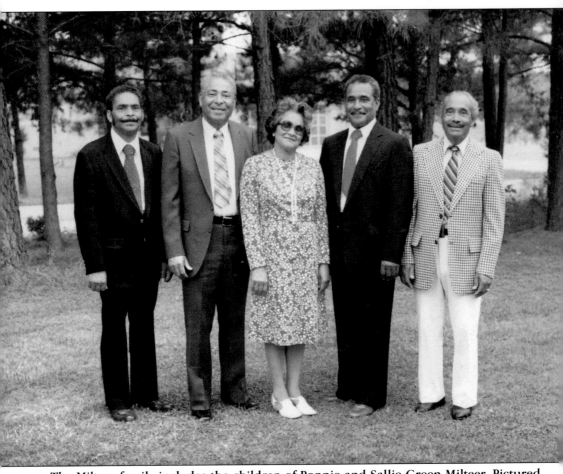

The Milteer family includes the children of Ponnie and Sallie Green Milteer. Pictured, from left to right, are Mr. Curtis Milteer, Eugene Milteer, Mrs. Lennis Milteer Collins, Mr. Luther Milteer Sr., and Mr. Felton Milteer. (Courtesy Curtis Milteer.)

Two

SCHOOL DAYS

Pictured here is the Nansemond Collegiate Institute class of 1932. The Institute was founded in 1890 by the Reverend William Washington Gaines, who served as the fourth pastor of First Baptist Church on Mahan Street. Founded as the Nansemond Normal and Industrial Institute, the school changed its name in 1930 to the Nansemond Collegiate Institute when the "normal school" was added. For nearly 50 years, the school operated under the leadership of five principals, four of whom were ministers. The Reverend William H. Morris served as the school's first principal until 1912 when Rev. James Harrell became the second principal. The third principal was a Mr. Bruce, whose background information and first name were never found. When Mr. Bruce left in 1919, the Reverend Thomas Johnson came and remained principal until 1925. The last principal, Prof. William Huskerson took leadership in 1926, and he remained until the school closed in 1939. (Courtesy Portsmouth Public Library.)

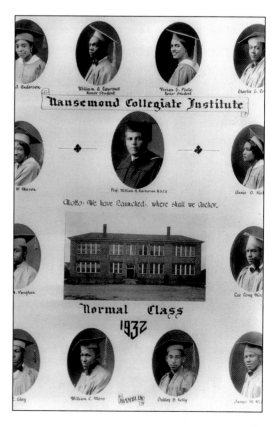

Prof. William A. Huskerson was an educator and principal of the Nansemond Collegiate Institute for over 15 years. Professor Huskerson was known for his leadership in black education and his ability to get things done. When a fire destroyed the school, he did much of the manual labor to rebuild it. Professor Huskerson was responsible for many of the graduates obtaining jobs, for he would drive students from county to county seeking employment. After the institute closed, Professor Huskerson went into the contracting business. He received a degree in civil engineering from Howard University and attended the First Baptist Church. (Courtesy Portsmouth Public Library.)

The Nansemond Collegiate Institute provided elementary and secondary education for black youth in Nansemond County. The institution was granted accreditation for its secondary school, making it the first in Nansemond County to receive this status. It also gained accreditation for the normal school by the Virginia State Board of Education, which made it possible for the school to train teachers and award teaching licenses. (Courtesy Renee Roper Jackson.)

Pictured here is Jordan Neighborhood House shown in 1952. Founded as a mission of the Universalist Church, the Jordan Neighborhood House provided education and health care to blacks in Suffolk and Nansemond County. (Courtesy Portsmouth Public Library.)

In 1904, Joseph Fletcher Jordan became the third African American to fellowship within the Universalist Church. He was appointed to lead the Suffolk Normal Training School in 1904. Known for his stern look and being direct, Reverend Jordan would closely observe the students in search of any sign of unkemptness that needed the attention of his comb. When Reverend Jordan died in 1929, the school was later renamed the Jordan Neighborhood House in his honor. (Courtesy Unitarian Universalist Association.)

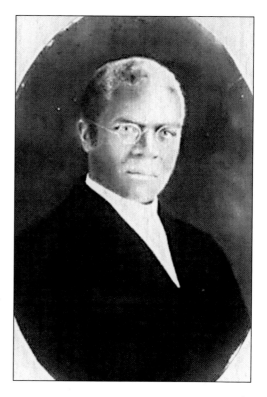

Mrs. Annie B. Willis was principal of the Suffolk Normal Training School, which was later named the Jordan Neighborhood School after her father, the Reverend Joseph F. Jordan, who served as the school's first principal. Facing the hardship of the Great Depression, "Miss Annie," as she was affectionately known, accepted the call and challenge to carry on the torch ignited by her father. Miss Annie was mostly known for being loving, a characteristic that made her a legend. (Courtesy Unitarian Universalist Association.)

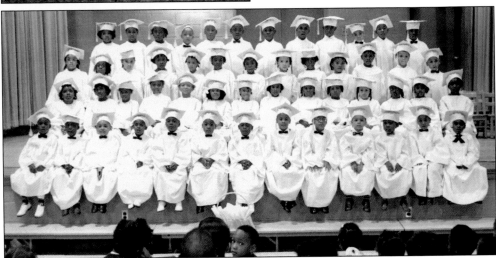

The 1960 graduates of the Jordan Neighborhood School kindergarten class from left to right are (first row) Nelson Thorne, unidentified, Fitz Turner, Rodney A. Doughty, Sylvester Ruffin, Larry Lane, unidentified, Bryon Hoffler, Byron Hoffler, Wilber Watts, Carl King, Ricky White, and Leonard Williams; (second row) Cynthia Deloatch, Brenda Alston, Gina Elliott, Angela Boone, Charlene Brown, Demetrius Watkins, Linda Wiggins, Lorraine Campbell, Theresa Boone, Ellen Jackson, Regina Milteer, Vicky Bailey, Sheila Carson, and Catherine Cook; (third row) Vickie King, unidentified, Donna Sullivan, Sharon Norfleet, Dolly Richards, unidentified, Deborah Boone, Cathy Hart, Rhonda Doughty, unidentified, Brenda Savage, Kaye Bellamy, and Aubrey Mitchell; (fourth row) Lelia Porter, Cynthia Finch, Margaret Wynn, Dennis Hill, Jonathan Williams, Richard Walker, Lloyd Hardie, Bubba Locust, Ronnie Cross, Alton Knight, Ricky Goodman, and Henderson Williams. (Courtesy Donna A. Sullivan Harper.)

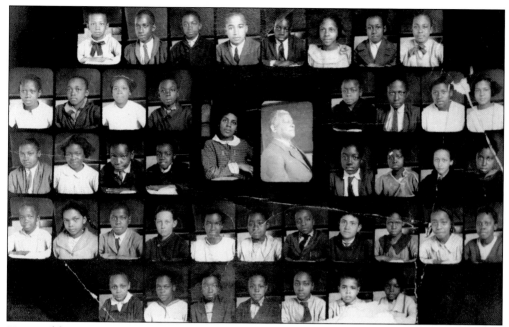

Pictured here are the Andrew J. Brown Elementary School students in the early 1920s. Mr. Andrew J. Brown (center, right) served as principal. (Courtesy Robert Kelley.)

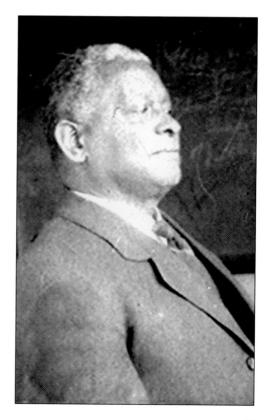

Andrew J. Brown was an educator and administrator in the Suffolk and Nansemond County School System. Mr. Brown was a member of several organizations including the Tidewater Fair Association. A school was named in his honor. (Courtesy Robert Kelley.)

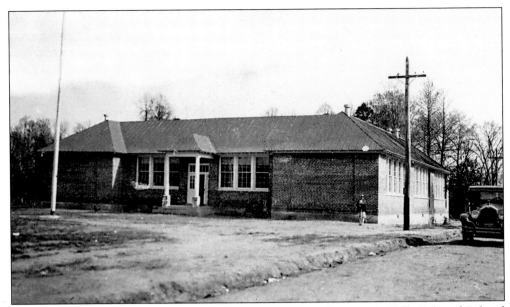

The East Suffolk School was sometimes referred to as the East Suffolk Colored School of Nansemond County in 1927. Established in the early 1920s, East Suffolk only served grades one through seven until 1939, when a high school was added. (Courtesy The Library of Virginia.)

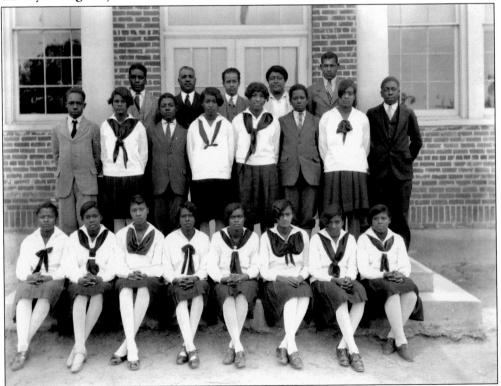

Pictured here are students at the East Suffolk School in 1928. (Courtesy The Library of Virginia.)

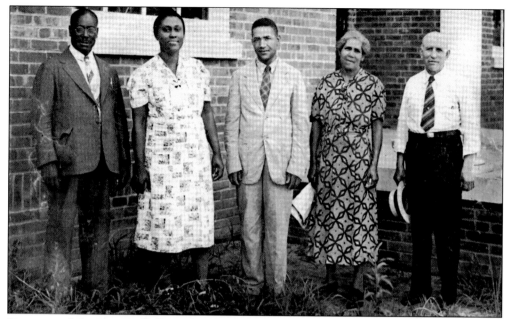

Pioneers of the East Suffolk High School appear in this photograph. From left to right they are Mr. Q. Davis, Mrs. G. M. Joyner, Mr. Willie White, Mrs. Bullock, and Mr. Wiley H. Crocker. (Courtesy Mary A. Davis.)

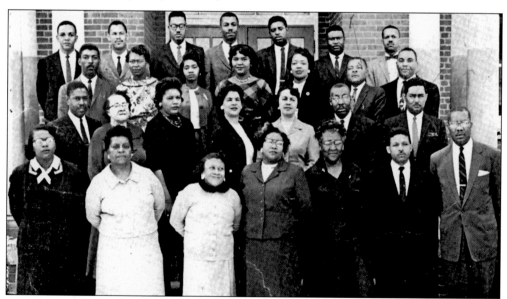

Members of the faculty of the East Suffolk High School in 1959 are shown here. From left to right, they are (first row) Evelyn Horton Jackson, Ethel W. Joyner, R. S. Whitfield, Mary P. Lewis, Lessie H. Knight, Mack Benn Jr., and W. Lovell Turner; (second row) David L. Watson, Helen C. Mitchell, Helen M. Spencer, Thelma F. Hamilton, Vivian P. Cuffee, A. A. Lewis, and Fitz Turner Jr.; (third row) James G. Barge Jr., Thelma Taylor Norfleet, Irma C. Burke, Clara L. Harris, Bertha Lee Crocker, Winifred T. Benn, and John E. Jones; (fourth row) Frank J. Valentine, Charles E. Jones, Herbert Briscoe Jr., Floyd F. Miller Jr., Edgar T. Rawles, James R. Harris, and Benjamin L. Davis. (Courtesy Mary A. Davis.)

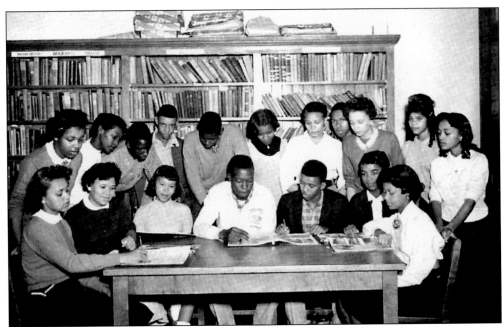

Members of the 1958 yearbook staff of East Suffolk High School from left to right are (first row) Darlene Cobb, Lillian Brinkley, Mary Byrd, James Riddick, Amos Irvin, Carol Boone, and Almeta Barnes; (second row) Martha Johnson, Mary Wynn, George Glee, Clifton Jones, John Moore, Evelyn Baker, Eleanor Copeland, Herbert Ricks, Brenda Boone, Vivian Costley, and Phyllis Boone. (Courtesy Mary A. Davis.)

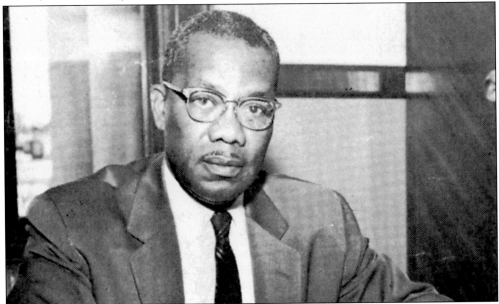

Mr. William Lovell Turner served as principal of East Suffolk High School from 1939 to 1965. He was also the director of instruction at the Nansemond Collegiate Institute during 1938 and 1939. Mr. Turner held many positions at East Suffolk due to the small staff. He taught U.S. government and had a homeroom class and performed secretarial duties. (Courtesy Mary A. Davis.)

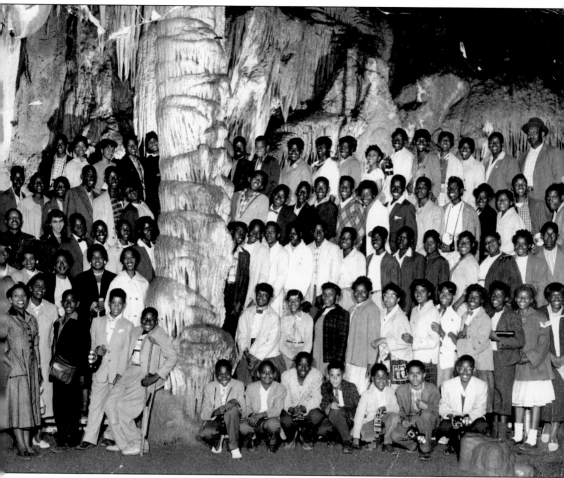

East Suffolk Middle School students are on field trip at Luray Caverns in 1957. For many years, Mrs. Bernice B. Maloney (far left, front) sponsored field trips for the students at East Suffolk Middle School. She has taken as many as seven busloads of students on field trips that were both educational and recreational. (Courtesy Bernice B. Maloney.)

> P. H. Holland's Policy number
> 1480229-C.
>
> A Copy of a Receipt for a School sist:
> 1914 March 3rd Received from the
> Silver P.F. School Patrons By J. R. Turner
> Jessie Bailey & Matthew Reid now standing
> as Trustees. Fifteen Dollars $15.00
> In full payment for one acre of Land
> for a Public Free School.
> & after the Patrons have
> met and Organized appined Pres- Sec
> Treasurer & Trustees. to take Care of
> their Business,
> I will make a deed to them
> School for the same —
>
> sign By M Jane Holland
> & W P Holland
>
> a little later the above body was organized a
> Pres- Secty Treas, was elected and 2 Trustees
> A J Holland & Matthew Reid was also

Here is a copy of a receipt for land donated by Mr. Axium J. Holland to build the Silver Springs School. Mr. Axium J. Holland wrote this receipt. Dated March 3, 1914, the amount of $15 was received for one acre of land for a public free school. Mr. J. R. Turner, Jessie Bailey, and Matthew Reid served as trustees. The receipt stated that once the patrons had met and organized its officers to take care of their business, a deed would be made to the school. (Courtesy Ruby H. Walden.)

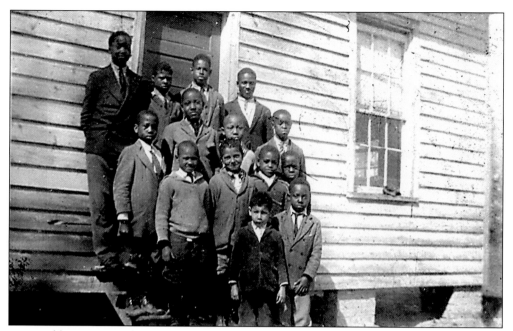

Pictured here are students at the Silver Springs School in Holland (Nansemond County) during the early 1920s. Mr. Axium Holland donated the land, and the black community built the school, which had two rooms. (Courtesy of Ruby H. Walden.)

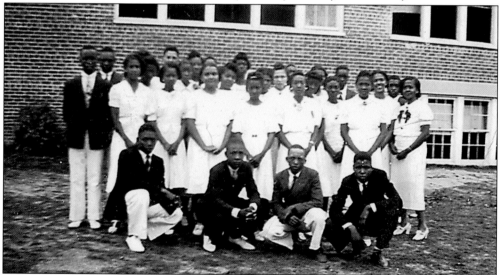

Nansemond County Training School was founded in 1924 in the Holland area and was the first black public school in Nansemond County. Pictured is a group of graduating seniors. Mr. Hannibal E. Howell was the school's first principal, and he served for 42 years. The school received its accreditation in 1931, and around 1955, a new facility was built. Following the retirement of Mr. Howell, Mr. Benjamin Davis became principal. Under his leadership, the school expanded to accommodate both high school and elementary-level students in 1964, and in 1965, the school was renamed Southwestern High School. The last class graduated from Southwestern High School in 1970, when it became a middle school. (Courtesy Ruby H. Walden.)

In 1953, the Nansemond Educational Committee filed a lawsuit to equalize public schools in Nansemond County. The purpose of the suit was to secure adequate schools, facilities, opportunities, and advantages for the black youth in Nansemond County. The group solicited funds to help prosecute the case, which was tried in the federal district court in Norfolk. Mr. Edward Jones served as chairman of the committee, and Mrs. Ruby H. Walden was secretary. (Courtesy Ruby H. Walden.)

Mr. Benjamin L. Davis Jr. was the first African American assistant superintendent of Suffolk Public Schools. Mr. Davis was also a teacher at East Suffolk High and principal at Southwestern High School. He served as president of the Nansemond County Teachers Association, the Virginia Association of School Administrators, and was a member of the Alpha Phi Alpha Fraternity, Inc. Mr. Davis served in the Armed Forces during World War II as a first lieutenant and received the Bronze Star Medal for heroic action. He was married to Mary A. Owens Davis, who also taught in the Suffolk Public School System, and they had one child. (Courtesy Mary A. Davis.)

Built in 1925 on Lee Street, Booker T. Washington School, a two-story building, was complete with 10 classrooms. In 1934, when an auditorium and two classrooms were added, the school advanced to a four-year state-approved high school. Prof. Edward D. Howe served as principal and Mr. J. Fenton Peele Jr. was the assistant principal. The first graduation of the Booker T. Washington High School was held in 1937. In 1953, a new high school was built on Walnut Street with Mr. J. Fenton Peele as principal. After the integration of public schools in 1969, Booker T. Washington High graduated its last class and thereafter became an intermediate school the following year. Since 1990, Booker T. Washington has served as an elementary school. (Courtesy John Riddick.)

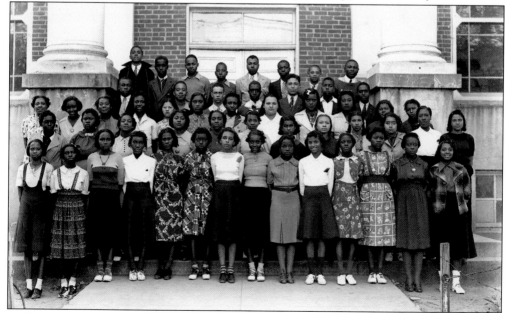

In this photograph are students attending Booker T. Washington High School in 1939. (Courtesy The Library of Virginia.)

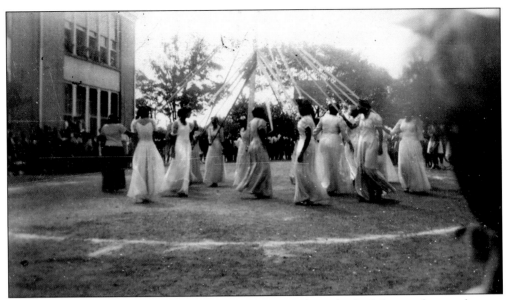

The May Day celebration was an event that the students looked forward to each year. In this photograph, young ladies from Booker T. Washington School, dressed in white gowns, wrap the maypole. (Courtesy Renee Roper Jackson.)

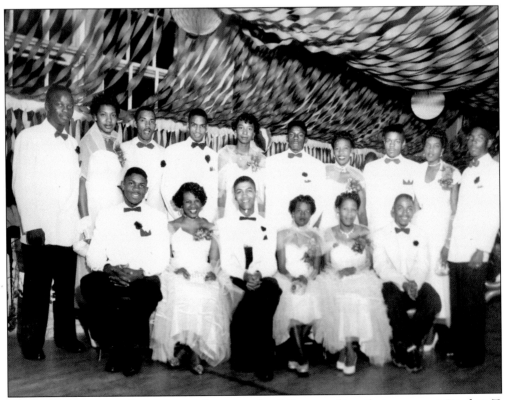

These students pose for a group photograph while attending their prom at Booker T. Washington High School during the 1950s. (Courtesy Renee Roper Jackson.)

This is a 1929 report card of Kennard Roper II, a seventh grade student at Booker T. Washington School. Miss Mattie C. Cohoon was the teacher. (Courtesy Renee Roper Jackson.)

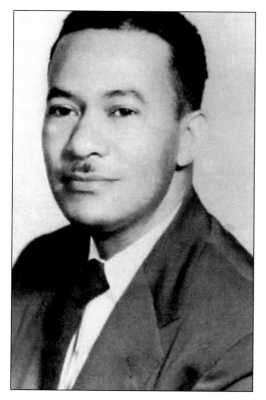

Mr. Elgin M. Lowe, pictured in 1960, was born in Southampton County in 1914 to Bishop Charles W. and Luzie A. Lowe. Mr. Lowe's family moved to Suffolk in 1917, when he was three years old. He was a 1932 graduate of the Nansemond Collegiate Institute and received a teaching certificate from the institute in 1934. Mr. Lowe began his teaching career at the Jefferson Elementary School in Sussex County. He also taught in Windsor and Isle of Wight County. When he was promoted to principal, he served at Camptown Elementary, Georgia Tyler High Windsor Elementary, and Booker T. Washington Junior High Schools. Mr. Lowe held other administrative positions, and served on the board of visitors at Virginia State and Norfolk State Colleges. He was the first black school principal in Virginia to be elected rector of the board of visitors at Virginia State College. Mr. Lowe authored several books, which include his autobiography. (Courtesy Sandra Lowe.)

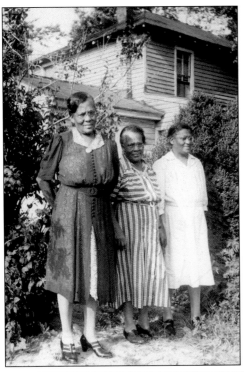

Mrs. Annie Vick, Mrs. Mary E. Estes, and Mrs. Helen Hunter were sisters and educators in the Suffolk School System. Mrs. Vick taught at Andrew J. Brown Elementary School. Mrs. Estes taught at the Nansemond Collegiate Institute and Mary Estes Elementary School, where she became principal, and the school was named in her honor. Mrs. Hunter also taught and eventually became principal in the Whaleyville area. The sisters resided side by side on Wellons Street. (Courtesy Mary A. Davis.)

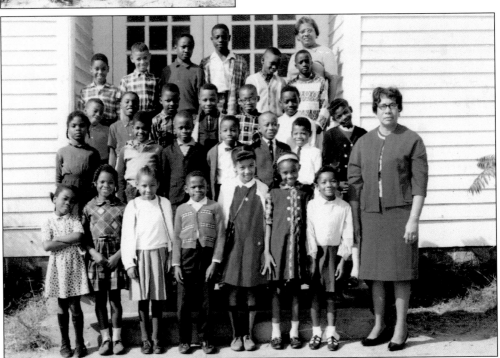

Pictured here is Mrs. Mary Alice Davis's third grade class of 1966 at Mary E. Estes Elementary School, located in South Suffolk. Mrs. Davis, teacher, is shown in the front right. Mrs. Beuhla Watts (back row, far right) was principal. The school was named for Mary E. Estes, who was formerly principal of the school. (Courtesy Mary A. Davis.)

Three
WORSHIP AND PRAISE

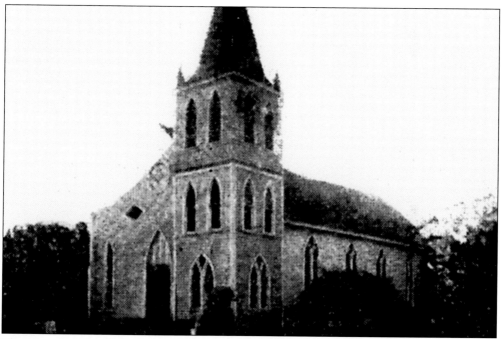

The First Baptist Church, located on Mahan Street, originally held services in an old house purchased from John R. Kilby by the Methodist congregation. The services were held alternately with the Methodists from 1866 to 1868. After the Methodists demolished the old house and moved to Pine Street, the Baptists moved to a rented, two-room, brick home at the corners of Main and Mahan Streets, where they worshipped until 1872. Historians have noted that this home once served as the headquarters of George Washington during the Revolutionary War. The first pastor of the church was Rev. Jordan Thompson, who also served as pastor of Little Bethel Church of Chuckatuck and Oak Grove Baptist Church. During the period between 1873 and 1891, the church grew under the leadership of the Reverend William Gaines, a graduate of Howard University and Wayland Seminary. A new structure was erected at its present site. Reverend Gaines was also the founder of the Nansemond Collegiate Institute. (Courtesy John Riddick.)

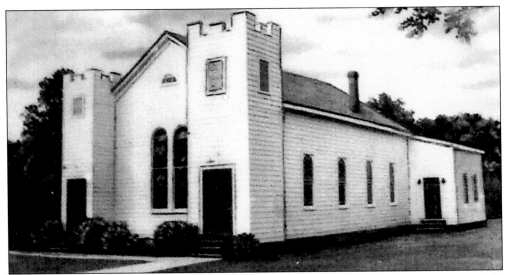

The Mt. Ararat Christian Church was founded in 1866, when the first services were held under a bush shelter. In 1872, members purchased the Old Salem Church, a Methodist building owned by a white congregation on the Old Desert Road. The members razed and erected another building on the present site. The building was a crude structure with no windows, and the Reverend Justin Copeland was the first pastor. Windowpanes and other improvements were not made until 1900 by Thaddeus Skeeter and Jack Baxter. Over the years, Mt. Ararat continued to progress, and under the leadership of the Reverend Raby J. Knight, a new church was built in 1988. (Courtesy Warren Milteer Jr.)

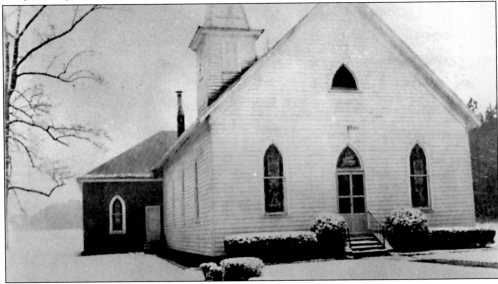

No dates have been recorded as to the beginning of the first assembly of the Zion United Church of Christ, but like all black churches during the period of Reconstruction, the first assemblies of worship date back to a bush shelter. The Reverend Robert Holland, pastor of Holy Neck Christian Church, preached for the people of the church each first Sunday evening. The Reverend Justin Copeland, a son of Zion, became the first black pastor. Under his leadership the church joined the Christian Conference in 1867. (Courtesy Zion United Church of Christ.)

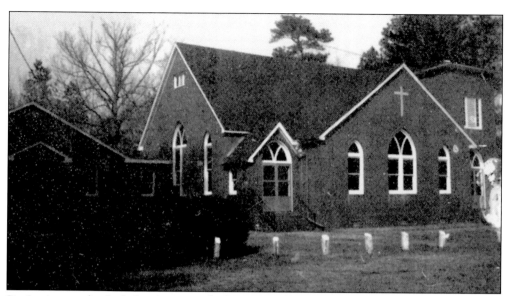

Beginning as a bush shelter in a pine thicket, Corinth Chapel was organized by the Reverend Louis Darden, who was also its pastor in 1868 during the period of Reconstruction. Between 1868 and 1908, this building was replaced by three other buildings. A mysterious fire destroyed Corinth's third structure. The design of the third church was described as one of the finest structures from Maine to Florida. During this time, the Reverend S. A. Howell was pastor. By overcoming obstacles and exhibiting headstrong leadership, Corinth continued to grow to a membership of nearly 300. (Courtesy Corinth Chapel.)

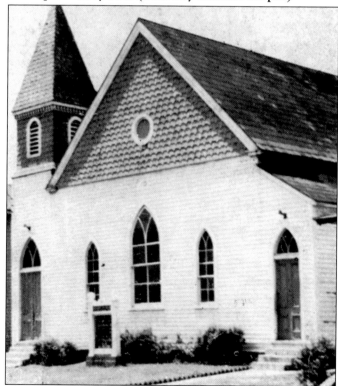

Reportedly established in 1870, the Macedonia African Methodists Episcopal Church originally evolved from the free African society organized in Philadelphia, Pennsylvania, in 1787 by the Reverend Richard Allen after a walk-out of the colored members of the St. George M.E. Church. Since its establishment, Macedonia has seen many pastors who contributed greatly to the church and has prospered both spiritually and in development. (Courtesy Macedonia A.M.E.)

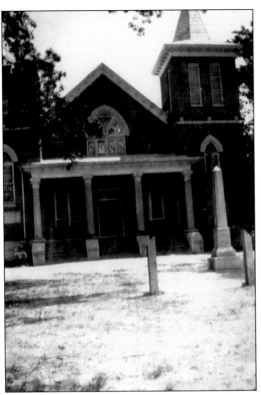

Mt. Sinai Baptist Church was organized in 1868 under the leadership of the Reverend Israel Cross. He was a member of the Reedy Branch Baptist, an all-white congregation. Reverend Cross encouraged all African American members from Reedy Branch to organize a church of their own. In 1821, the congregation replaced the original structure with a frame building, and when the congregation outgrew the building, another edifice was erected. Reverend Cross often stressed that Christian religion, education, and worship of land should be the sole purpose of every individual, and he is given credit for the number of landowners in their community today. (Courtesy Flora W. Chase.)

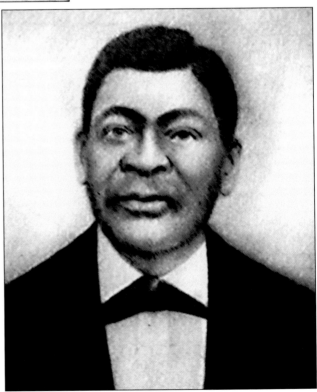

Pictured here is the Reverend Israel Cross, pastor of the Mt. Sinai Baptist Church. (Courtesy Ruby H. Walden.)

The history of Canaan Baptist Church dates as far back as 1875. The church was set up on what was known as Wiggins Grove but was properly the Wilroy area of Suffolk. The church was started by 12 people of the community who felt the need to have a church. The first building of worship belonged to Mr. Dempsey Wiggins, and the Reverend J. W. Sumner served as its first pastor. Under the leadership of Pastor Sumner, an acre of land was purchased for a new place of worship, and the new facility was called Canaan. (Courtesy Canaan Baptist Church.)

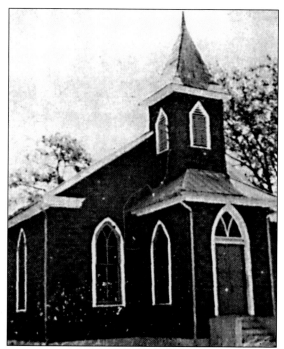

Laurel Hill Church of Christ's first building was the size of a large room. It was reported that, in 1877, Jack Jones, a former slave, asked a white minister, the Reverend R. H. Holland, to give the black people a place on the hill so they could have their own church and burying ground. Holland honored that request. Together with his sons, Walter and Jackson Howell, Mr. Jones erected the first church. Rev. R. H. Holland served as the first pastor. In 1885, Reverend Holland rebuilt the church farther up the hill beside a laurel tree. Thus, the church was named Laurel Hill Christian Church. Pastor Holland served until he found a suitable preacher, and the Reverend Frank E. Jordan became the first black pastor; he served until his death. (Courtesy Therbia Parker.)

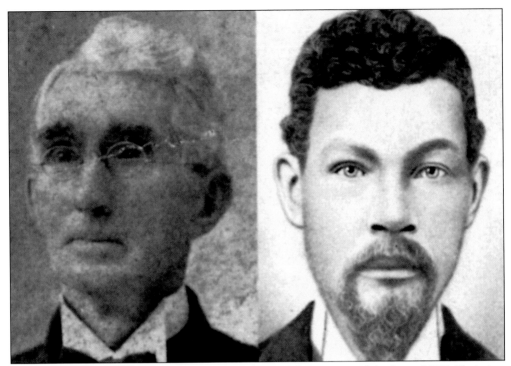

The Reverend R. H. Holland (left) was founder and first pastor of the Laurel Hill Christian Church. He gave the land for the building and the cemetery. Rev. Frank E. Jordan (right) was the first African American pastor of Laurel Hill. He was ordained by Reverend Holland and served until he died in 1899. (Courtesy Therbia Parker.)

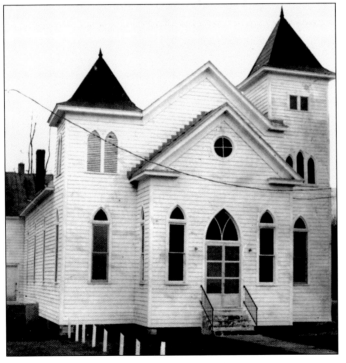

The Reverend Israel Cross, who felt the need to build a church in the Buckhorn area of Suffolk, initiated Piney Grove Baptist Church in 1878. The church got its name, "Piney Grove" when it was first organized under a bush shelter among pine trees. It was also where the first building was erected. This one-room structure served as a place of worship for many years until a larger building was erected on a site donated by a white friend on what is now known as Deerpath Road. (Courtesy Piney Grove Baptist Church.)

First known as the Fairground Baptist Church on Polk Street in Suffolk, Metropolitan Baptist Church was organized in 1886 under the leadership of the Reverend Simon Boozier. In 1889, a parcel of land was purchased on Tyne Street and the church, a frame structure, was built. Historical data has noted that a member of the church by the name of H. C. Christmas was responsible for the name of the church being changed to Tyne Street Baptist Church. Under the administration of the late Rev. D. W. Lamb of Elizabeth City, North Carolina, the building was extended from Tyne Street, which is the entrance to the educational department, to County Street, which is the is the entrance to the present sanctuary. The name of the church was finally changed to Metropolitan Baptist Church in 1955. (Courtesy The Library of Virginia.)

Organized in 1888 by a group of 26 former members of the First Colored Baptist Church located on Mahan Street, the Fourth Colored Baptist Church first held services in Israel Temple on Smith Street, and later in Suffolk Town Hall on the corner of North Main and Market Streets. The Reverend L. W. Melton served as the first pastor. After construction of the new worship chapel on Pine Street, the church's name was changed from the Fourth Colored Baptist Church to the Pine Street Baptist Church. The church's next move was to its present site on the corner of East Washington and Mulberry Streets in 1924 under the leadership of the Reverend T. J. Johnson. During the administration of the Reverend Clarence J. Word in 1942, the name of the church was changed to East End Baptist Church. (Courtesy The Library of Virginia.)

Originally called Antioch Christian Church, the Antioch United Church of Christ was first organized as a Sunday school under the direction of Mr. A. B. Lee. The name was changed after 1951 when the United Church of Christ was organized. Antioch UCC was located on St. James Avenue in the Saratoga-Philadelphia section of Suffolk on property deeded by Robert R. and Laura T. Smith. The first choir was organized in the late 1900s, and eventually, its membership grew. Antioch has had a host of pastors through years; each has been instrumental to the growth and development of the church. (Courtesy Antioch United Church of Christ.)

The Antioch United Church of Christ was relocated in 1972 to this present site on the corner of Hull and Kilby Avenues in the Saratoga section of Suffolk. (Courtesy Antioch United Church of Christ.)

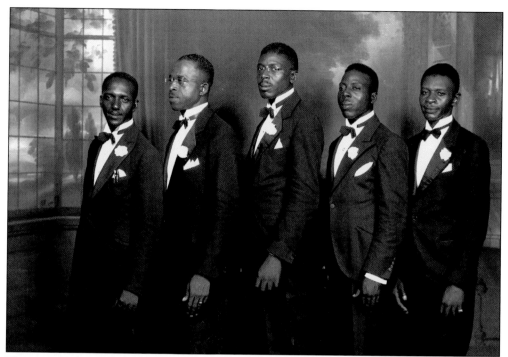

This is a 1941 photograph of the Suffolk Jubilee Quartet, a gospel-singing group that held concerts throughout the city and county. (Courtesy The Library of Virginia.)

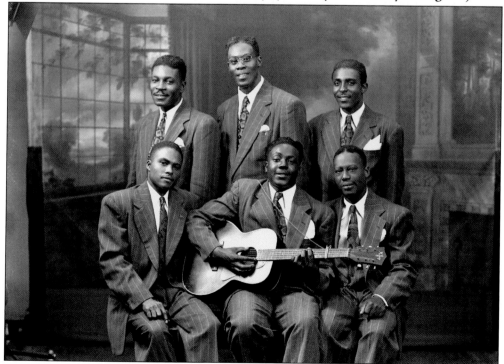

The Pearly Gates Quartet became locally and nationally known for their inspirational songs of praise. They are pictured during November 1947. (Courtesy The Library of Virginia.)

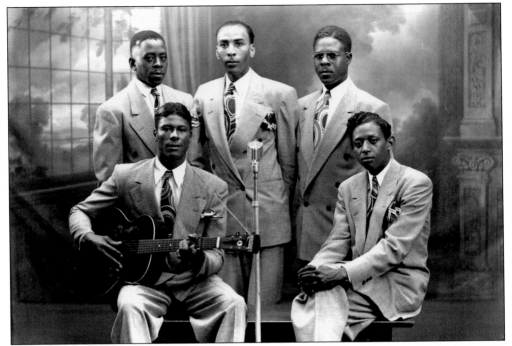

The Faithful Four Quartet is pictured in November 1948 from left to right: (first row) Walter Beale and Madison Artis; (second row) Leroy G. Smith, Henry Everette, and Charlie Long. (Courtesy The Library of Virginia.)

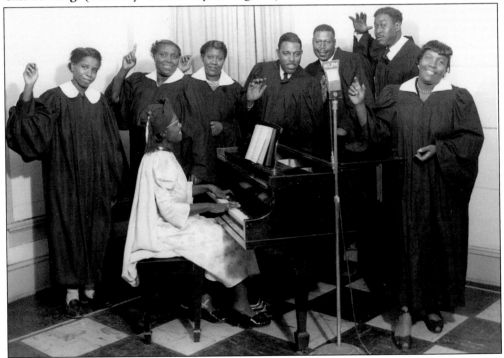

This is a photograph of the International Soul Steiners, a gospel singing group, in December 1948. (Courtesy The Library of Virginia.)

Four

BUSINESSES, PROFESSIONS, AND LABOR

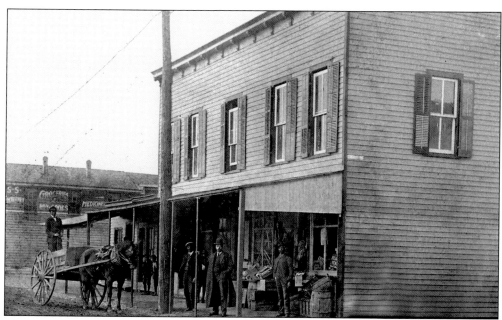

The Roper Grocery Store in 1907 was located on the corner of East Washington and Liberty Streets. Owned by George and Cora Roper, the building housed the grocery business on the first floor, and the family lived on the upper level. This photograph featuring customers standing in front of the store was used on a postcard to advertise the business. (Courtesy Renee Roper Jackson.)

George Roper, a prominent pioneer businessman, was the owner of Roper Grocery Store on East Washington Street. He was also a postal worker with the U.S. Postal Service. Mr. Roper was a charter member of the Nansemond Development Company, Inc., where he served as chairman and secretary in the 1930s. He was also a charter member of the Tidewater Fair Association as well as a member of its board of directors. (Courtesy Renee Roper Jackson.)

300 Choice Lots For Sale
On the Norfolk-Richmond Highway, near the corporate limits of Suffolk, Virginia

These are the very best residence lots near Suffolk, and the odly section with Electric Light Line. The lots are sure to dovble in value in five years. Don't miss this chance to get a lot.

Prices, $115 to $250
$5 and $10 Cash and $1 and $2 a Week
Guaranteed Title

The Nansemond Development Company was founded in 1908 by James T. Reid Sr., Lonnie L. Reid, Junius White, Wiley H. Crocker, and George Roper. The company purchased land that extended from Division Street to the Norfolk & Western Railroad (East Washington underpass). In addition to purchasing land, the Nansemond Development Company also built homes and businesses, which they sold and rented. They owned the Colossal Hotel, formerly located in the building, which is now owned by Local 26, a labor union, as well as the Phoenix Bank. Above is a 1917 advertisement showing lots for sale. (Courtesy *New Journal and Guide*.)

The Phoenix Bank of Nansemond opened its doors on March 15, 1919, with resources of $13,000. The bank was founded by Dr. William T. Fuller, a physician, to help black laborers and farmers in Suffolk and Nansemond County. Dr. Fuller served as president from 1919 until his untimely death in 1921. That year, the bank moved into its new facility, which was designed by Dr. Harvey N. Johnson, who also designed the Attucks Theater in Norfolk. The modern two-story facility of brick and stone was built at a cost of $25,000. After the passing of Dr. Fuller, Mr. John Richardson, who served as first vice president of the bank, was chosen as president to fill the unexpired term of the late Dr. Fuller. By this time, the bank's capital had reached $125,000. The officers affiliated with the bank in 1921 were Andrew J. Brown, H. C. Askew, and C. S. Baker. The directors included Mr. Richardson, C. H. Davis, A. J. Brown, David Epps, James Coach, Lonnie L. Reid, J. L. White, E. L. H. Rance, J. C. White, G. H. Pugh, G. W. Brown, J. A. Harrell, Luther Colden, D. T. Howell, J. F. Peele, and T. W. Colden. The bank closed in 1937 due to lack of funds and support. (Drawing by Steve Craddock.)

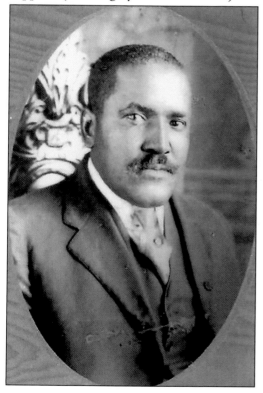

Mr. John Richardson was one of the first principal founders of the Phoenix Bank. He continued to serve as president until the bank's closing around 1937. During the time that Mr. Richardson was president of the Phoenix Bank, he was also a janitor at the white-run American Bank and Trust Company in Suffolk. He was featured in a 1940 "Ripley's Believe It or Not" column for serving as president at one bank and janitor of another at the same time. Mr. Richardson was instrumental in bringing to the bank many strong and influential friends. He died in 1939. (Courtesy Robert Kelley.)

JOIN OUR CHRISTMAS SAVINGS CLUB

Because:

It teaches you Systematic Saving

It insures you a Comfortable Christmas

It causes you to have Money that you otherwise would have spent.

Join One or More of the Following Classes:

CLASS 25—Members pay 25c per week for 50 weeks, and receive $12.50, plus interest
CLASS 50—Members pay 50c per week for 50 weeks, and receive $25.00, plus interest
CLASS 100—Members pay $1.00 per week for 50 weeks and receive $50.00, plus interest.

JOIN NOW DON'T DELAY

Phoenix Bank of Nansemond
Suffolk, Virginia

OFFICERS:

W. T. FULLER, President A. J. BROWN, 2nd Vice-President
J. W. RICHARDSON, 1st Vice-President THEO. W. COLDEN, Cashier

This is a 1921 advertisement for the Phoenix Bank of Nansemond. (Courtesy *New Journal and Guide*.)

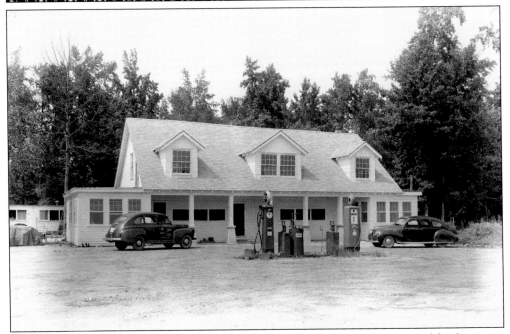

The LaGoon Restaurant was owned by Mary Cross Pierce and operated by her son, Mark Pierce. The restaurant was located on Portsmouth Boulevard, and in addition to dining, the establishment offered gas and later expanded to motel accommodations. Organizations often held meetings and other gatherings at the LaGoon. (Courtesy The Library of Virginia.)

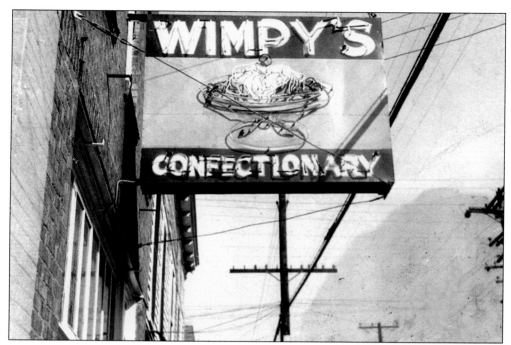

Here is a close-up view of the Wimpy's Confectionary sign. The name "Wimpy" was chosen for co-owner, Winifred Benn, whose nickname was Wimpy, from the character in the Popeye comic strip. (Courtesy Renee Roper Jackson.)

On July 1, 1947, a city license was purchased to open the Wimpy's Confectionary. The license was granted to Porter E. Walker, Winifred Benn, and Kennard Roper II, who were co-owners of the business. (Courtesy Renee Roper Jackson.)

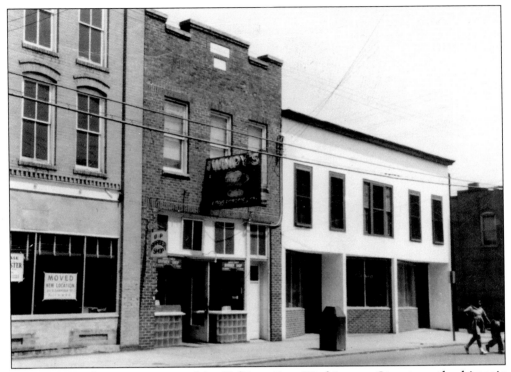

Wimpy's Confectionary opened in 1947 on East Washington Street on the historic Fairgrounds. It operated under the partnership of Porter E. Walker, Winifred Benn, and Kennard Roper II, who decided to open the business when they returned home from the serving in the military. Wimpy's was the meeting place for adults and students alike to get together to study or just socialize. (Courtesy Renee Roper Jackson.)

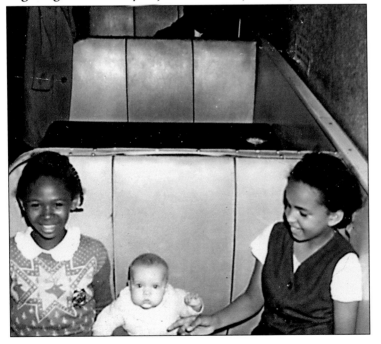

Sitting in a booth inside Wimpy's, from left to right, are an unidentified friend, baby Renee Waker Roper, and Nikki Jill Roper. (Courtesy Renee Roper Jackson.)

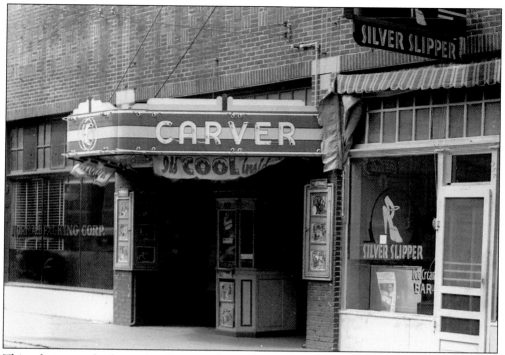

This photograph shows businesses that operated on The Fairgrounds. The Norman Packing Corporation (left) specialized in meats and staples. The Carver Theater, though it was white-owned, was the only theater for blacks. To the right of the theater is the Silver Slipper Restaurant. (Courtesy Portsmouth Public Library.)

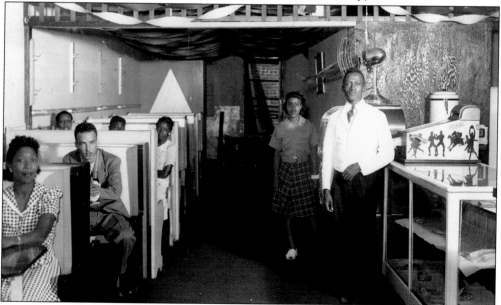

The Silver Slipper Restaurant, owned by Mr. Langstroth Fortune, was located in the 300 block of East Washington Street. The restaurant offered a variety of foods, from a steak dinner to sandwiches, and had an ice cream bar. It was a popular restaurant for dining and entertaining. (Courtesy Portsmouth Public Library.)

Mr. Wiley H. Crocker was a prominent business and fraternal man and a founder of the Tidewater Fair Association, for which he was president at the time of his death in 1943. Mr. Crocker was by profession a mortician and actively engaged in the undertaking business until 1920, when he became interested in real estate. He opened an office in what was then considered the "colored" business district on East Washington Street. Mr. Crocker was also one of the original incorporators of the Nansemond Development Company, a business that carried on extensive property developments in the city of Suffolk and Nansemond County. (Courtesy Jessie Trent.)

Mr. William T. Crocker was one of the founders of the Crocker Funeral Home, which was founded in the early 1900s. The undertaker business began as a partnership with his brother, Wiley, and Mr. John Boykins. After Mr. Boykins left in 1920 to start Boykins Undertaking Service, and Mr. Wiley Crocker went into real estate, Mr. William Crocker continued to manage the funeral home, which was incorporated in 1932, until his death in 1960. The company continues to operate today as one of the oldest black businesses in Suffolk. (Courtesy Flora W. Chase.)

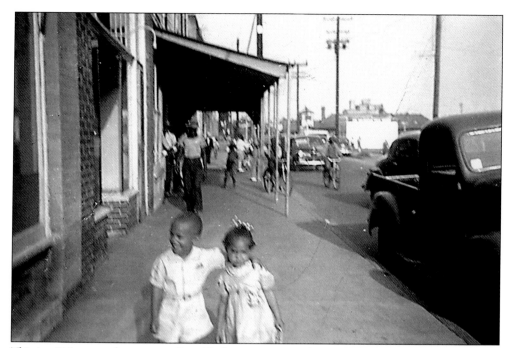

This is a Fairgrounds scene on East Washington Street during its heyday. In the foreground are Kennard III and his sister, Barbara. (Courtesy Renee Roper Jackson.)

John H. Fulcher was one of the first blacks to practice law in Suffolk. He arrived in Suffolk in 1926 and opened an office on the East Washington Street Fairgrounds. He practiced law until his death in September 1963. He was known and accepted as a good lawyer and a man of integrity. Mr. Fulcher married Georgiana Harrington in 1917, and of that union, came six children. In the Hollywood section of Suffolk, a street was named in his honor for the many contributions he made to the black community. (Courtesy Ernette Fulcher Reid.)

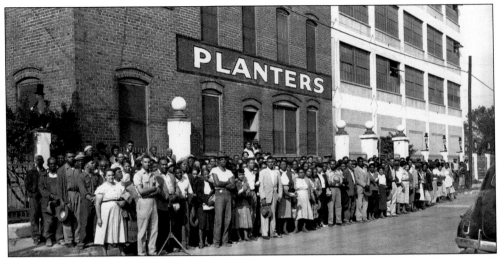

In this 1951 picture, workers employed by Planters Peanuts pose for a group photograph as members affiliated with Local 26 union. (Courtesy The Library of Virginia.)

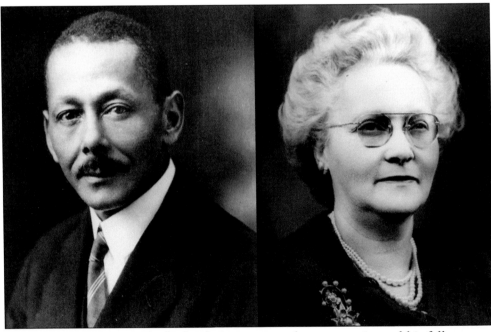

Thomas (Tommy) E. Cooke had a desire to serve the community and his fellow man. In 1924, he and his wife, Lessie, founded the T. E. Cooke Funeral Home, located at East Washington and Tyne Streets in the vicinity of Suffolk's prominent black business district. In 1957, Mr. Cooke relocated the establishment a block over to its present address on Johnson Avenue. When the opportunity presented itself, Mr. Cooke purchased the building in which he was operating his business. When Tommy Cooke died in 1962, his widow, Mrs. Lessie Cooke, renounced her rights and appointed persons to assume the operation of the business. The business's success continues today under the leadership of the new owners of the New T. E. Cooke-Overton Funeral Home. (Courtesy New T. E. Cooke-Overton Funeral Home.)

Little Barbara Roper enjoys her lollipop while standing along East Washington Street. In the background are the Nansemond Cleaners and the Nansemond Mattress Company. (Courtesy Renee Roper Jackson.)

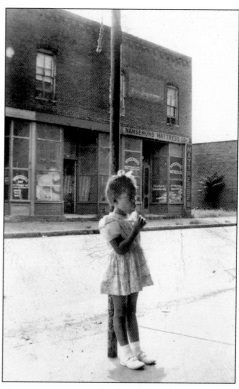

In 1949, the Nansemond Credit Union was founded by the Reverend Clarence J. Word (third from left) along with 11 others. Their mission was to help those who had difficulties receiving loans at banks and other financial institutions. It also served as a place where black community members could save their hard-earned money. The credit union continues to strive to uphold its mission to assist persons in financial need. (Courtesy The Library of Virginia.)

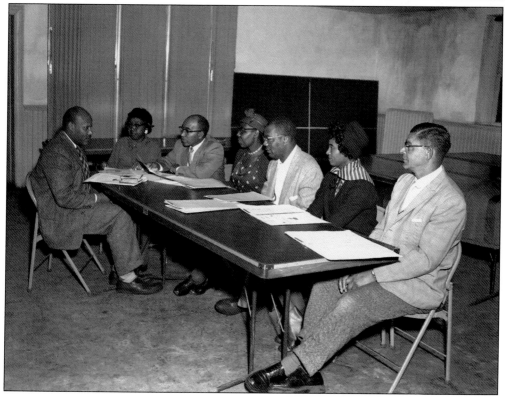

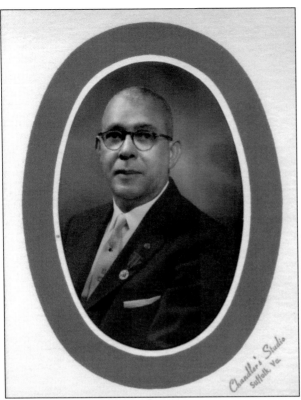

Mr. Ayler C. Faulk was a prominent businessman who owned a dry cleaning business in the Holland section of Nansemond County. In addition to operating his business, Mr. Faulk was involved in numerous social organizations. (Courtesy Ruby H. Walden.)

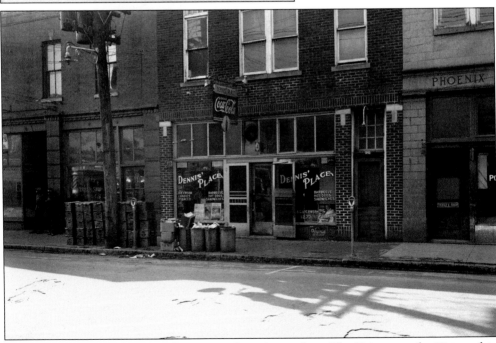

This is a 1944 outside view of Dennis' Place, located on The Fairgrounds. Pictured to the right of Dennis' Place is the Phoenix Bank building, which closed in 1939. (Courtesy The Library of Virginia.)

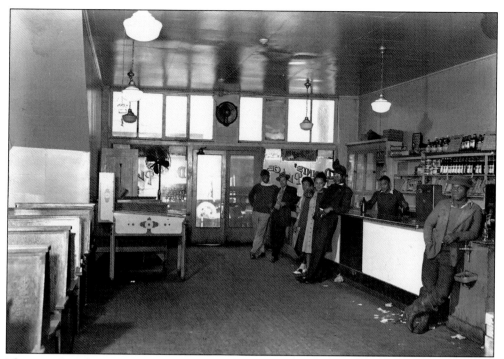

This is an inside view of Dennis' Place, a local hangout for young teens to mingle while listening to music and playing games. (Courtesy The Library of Virginia.)

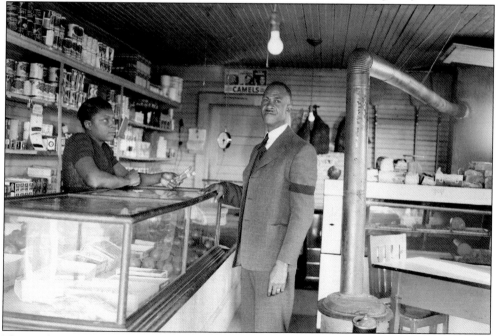

This 1943 country store was one of many black-owned businesses throughout Suffolk and Nansemond County. These neighborhood stores were a convenience to those who didn't have transportation to travel to the city to purchase goods. (Courtesy The Library of Virginia.)

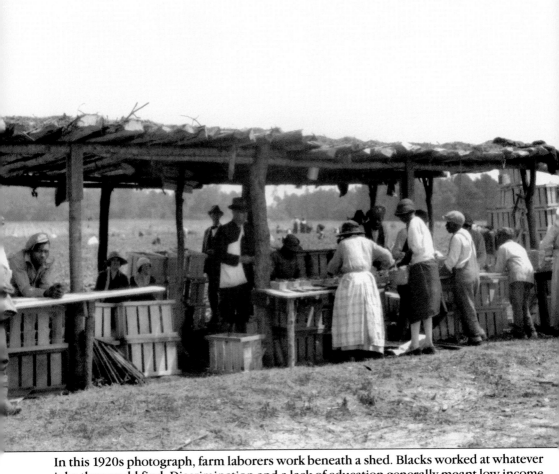

In this 1920s photograph, farm laborers work beneath a shed. Blacks worked at whatever jobs they could find. Discrimination and a lack of education generally meant low income and often menial work for African Americans. (Courtesy The Library of Virginia.)

Five
SOCIAL ORGANIZATIONS AND EVENTS

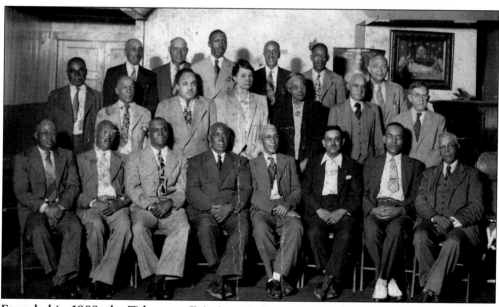

Founded in 1909, the Tidewater Fair Association sponsored an annual Tidewater Fair, which began as the Nansemond County Farmers Conference. The conference's purpose was to help farmers improve their farming skills. The fair grew to become an occasion not only for farmers to get together, but for the black community as well. Visitors to the fair, held in October, witnessed exhibits, demonstrations, and listened to speeches. The exhibits included farming, homemaking, and education and involved demonstrations. There were Farmers Day, Ministers Day, Educational Day, and Women's Day that consisted of speakers. Other attractions included horse racing, band concerts, and fireworks, and in later years, rides and games were added. The Tidewater Fair ended in 1979. (Courtesy Renee Roper Jackson.)

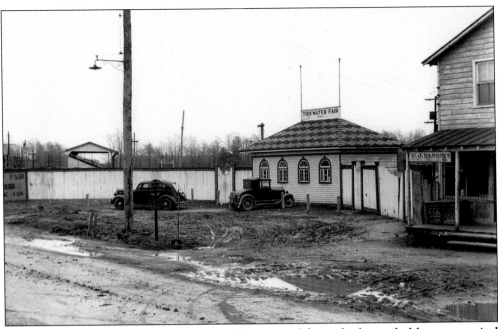

The Tidewater Fairground was the site of the annual fair, which was held over a period of four days in October. Pictured in the background (left) is the racetrack stadium. (Courtesy Portsmouth Public Library.)

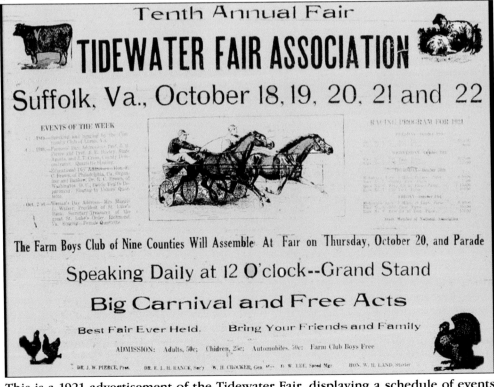

This is a 1921 advertisement of the Tidewater Fair, displaying a schedule of events. (Courtesy *New Journal and Guide*.)

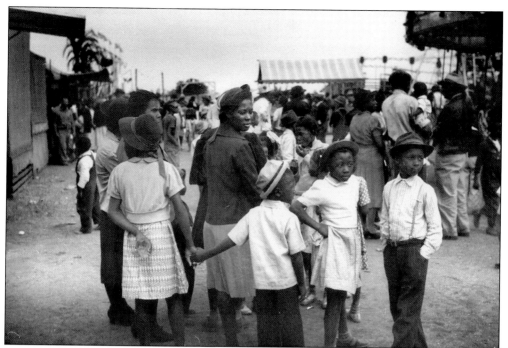

Visitors attend the Tidewater Fair, which became a family event. (Courtesy Portsmouth Public Library.)

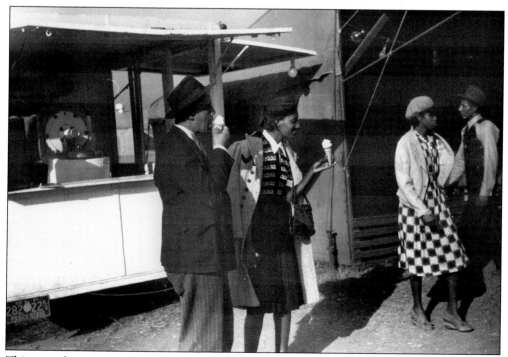

This couple enjoys an ice cream cone at the Tidewater Fair, while others take in the many sights. (Courtesy Portsmouth Public Library.)

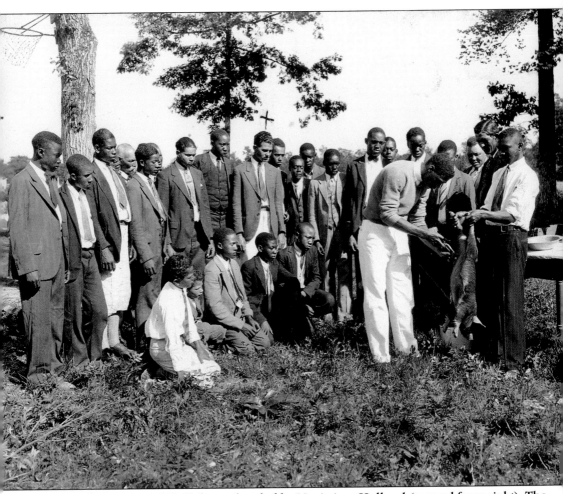
The Silver Springs 4-H Club was headed by Mr. Axium Holland (second from right). The group observes a demonstration on how to inoculate a pig. Mr. Howard Reid (third from right) was the county's farm agent. (Courtesy Ruby H. Walden.)

The Nansemond County Executive Committee attends a county season in October 1969. Pictured from left to right are Mr. Moses Riddick, Mr. Wyatt, Mr. Ocie Porter, and Mr. Floyd Bowers. (Courtesy John Riddick.)

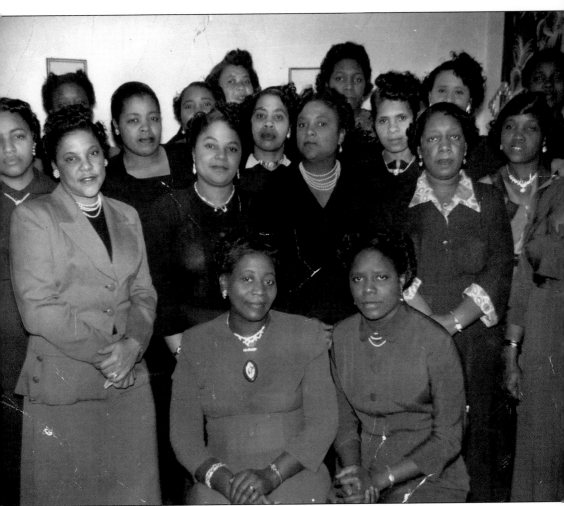

The Suffolk Beauticians Club, pictured here on February 18, 1952, recently disbanded in 2004. The members from left to right are (first row) Clementine Puryear, president, and Ester Privledge; (second row) Doris Akins, Mary Allen Boone, Thelma Everett, Doris Beamon, and Candace Darden; (third row) unidentified, Gracie Bullock, Polly Beamon, Thelma Hicks, and Beatrice Luke; (fourth row) two unidentified people, Bessie Sharp, unidentified, Georgia Pope, and Elizabeth Artis. (Courtesy Renee Roper Jackson.)

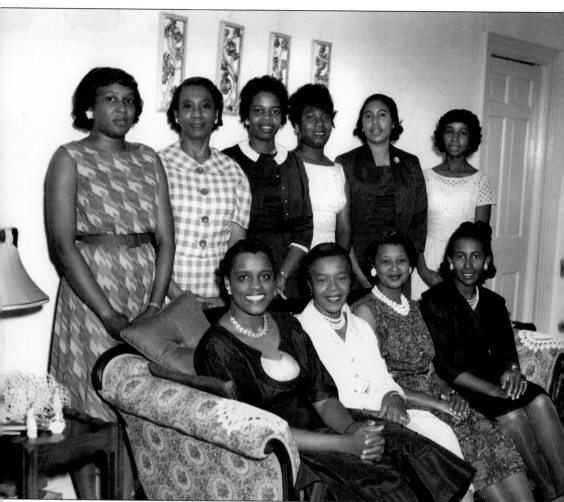

Pictured here is the Omega Chapter of the Chi Eta Phi Sorority, Inc., an organization of professional nurses. Members shown from left to right, are (seated) Mrs. Katie Lea Bass (chapter's founder), Naomi Clark, Mary Edmond, and Carnez M. Hunter: (standing) Marion Godwin, Emma Porter, Orprah West, Mattie Brett, Mary Hall, and Cleo Myrick. (Courtesy Mrs. Katie Lea Bass.)

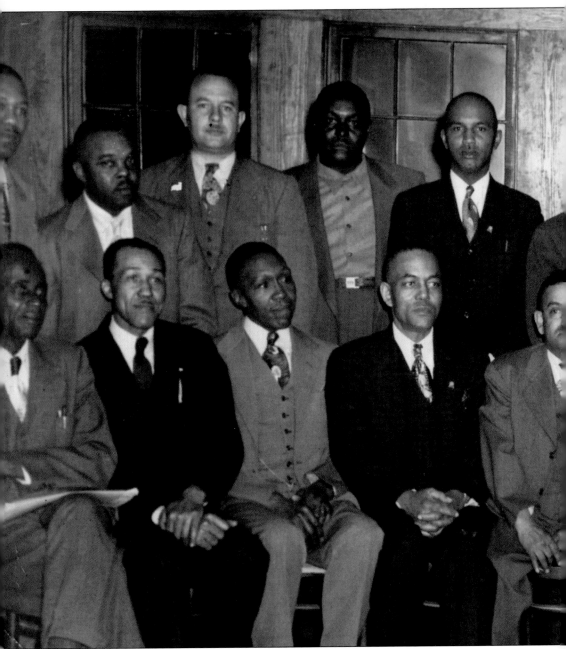

Members of the Suffolk Chapter of the Frontiers of America, Inc., posed for this March 1951 photograph after witnessing the presentation of their newly formed charter, which took place at the LaGoon Restaurant. Members from left to right are (seated) P. J. Chesson, national organizer; William C. Moss Sr.; Dr. Harvey M. Diggs; William R.

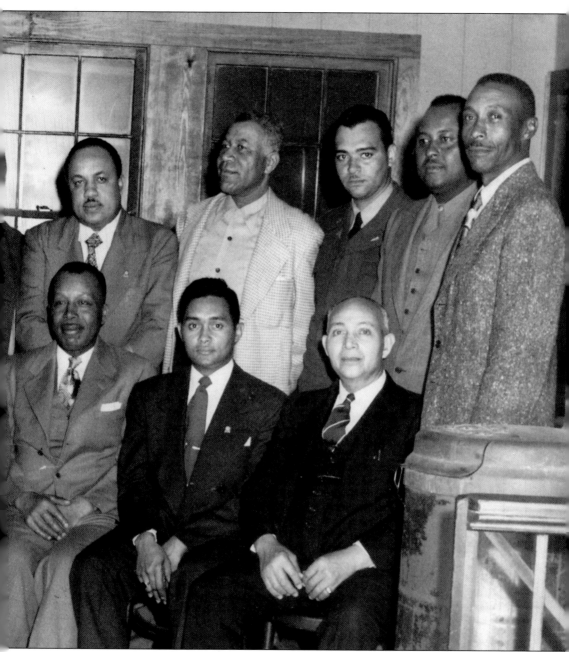

Taylor; H. C. Holman, president; John H. Fulcher; Fritz Turner, secretary; and Obadiah Walden; (standing) W. Lovell Turner; Sidney A. Estes; Fenton Peele Jr.; S. V. Walker; Rev. D. W. Lamb; Dr. R. H. Bland; Kennard S. Roper; Dr. T. A. Graham, Dr. Lonnie T. Reid, J. L. Edwards; and Mark Pierce. (Courtesy *New Journal and Guide*.)

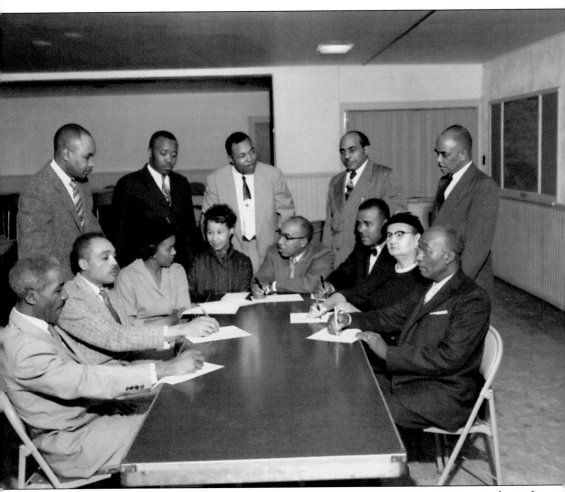

Members of the Suffolk Chapter of the NAACP in September 1957 prepare to host the annual convention of the Virginia State Conference of Branches of the NAACP. Seated from left to right are James C. Heck, Wesley Benn, Mrs. C. B. Chambliss, Dr. Margaret W. Reid, The Reverend Clarence J. Ward, Samuel Glover, Mrs. James White, and W. L. Outlaw. Standing from left to right are Jesse Freeman, Moses A. Riddick, Charles Cuffee, W. R. Wright, and Dr. C. M. Colden. (Courtesy *New Journal and Guide*.)

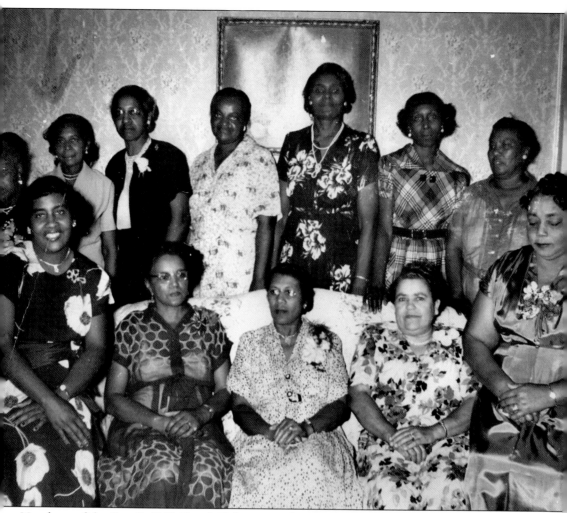

Members of the East Suffolk Floral Club in 1955 from left to right are (seated) Mrs. Crute, Mrs. Buck, Mrs. Sykes, Mrs. Finch, and Mrs. Boykins; (standing) Mrs. Minerva Smith Kindred, Mrs. Mamie Scott Benn, Mrs. Jenkins, Mrs. Helen Wilson, Mrs. Katie Lea Bass, Mrs. Doris Smith, and Mrs. Clemmons. (Courtesy Bernice B. Maloney.)

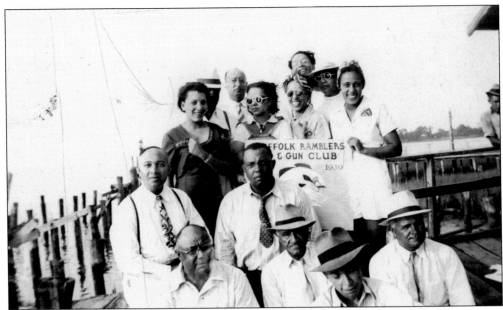
Members of the Suffolk Ramblers and Gun Club are pictured in 1939. (Courtesy Renee Roper Jackson.)

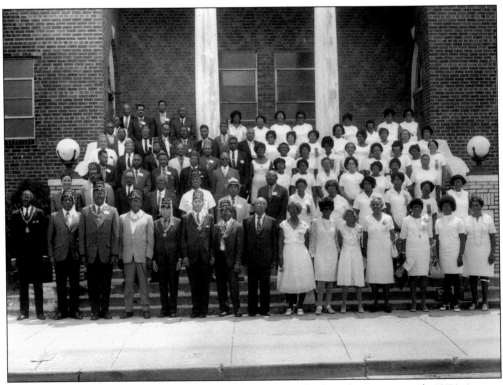
The Odd Fellows, pictured here with the Household of Ruth in August 4, 1971, is one of many benevolence societies. (Courtesy United Order of Odd Fellows.)

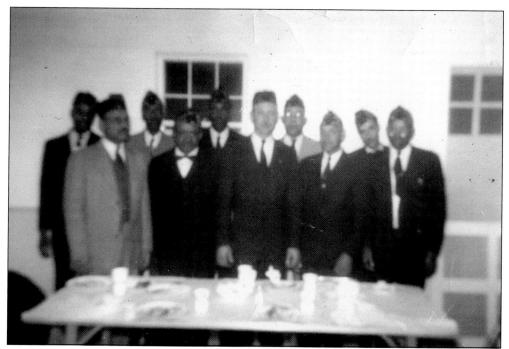

Pictured here are members of the Holland chapter of the American Legion, Post #315. This was a community service and veterans organization. (Courtesy Ruby H. Walden.)

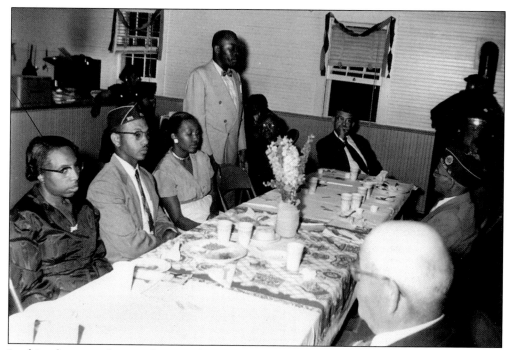

In this photograph, members and guests of the American Legion attend a social event. (Courtesy Ruby H. Walden.)

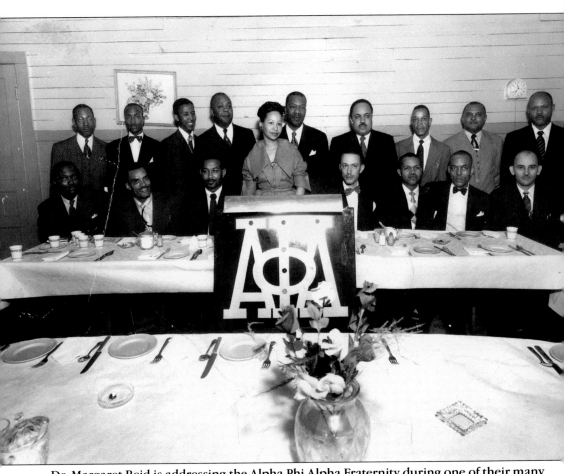

Dr. Margaret Reid is addressing the Alpha Phi Alpha Fraternity during one of their many societal affairs. (Courtesy Renee Roper Jackson.)

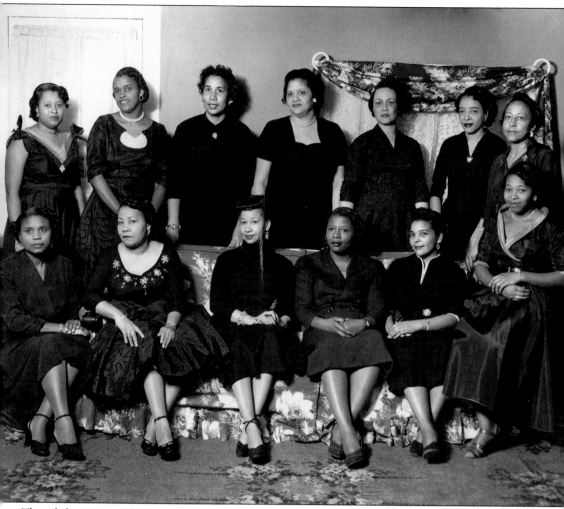

The Alpha Wives (also known as the Alpha-Bets) were organized in January 1954. This group of distinguished women consisted of the wives of members of the Alpha Phi Alpha Fraternity, Inc. They supported their husbands' organization and worked in the community. Pictured from left to right are (seated) Delia Cook, Gladys Turner, Margaret Reid, Evelyn Jackson, Dorothy Armistead, and Ruth Hopkins; (standing) Virginia Boone, Katie Bass, Mary A. Davis, Thelma Richardson, Juanita Barnes, Marie Sykes, and Vivian Pretlow. (Courtesy Katie L. Bass.)

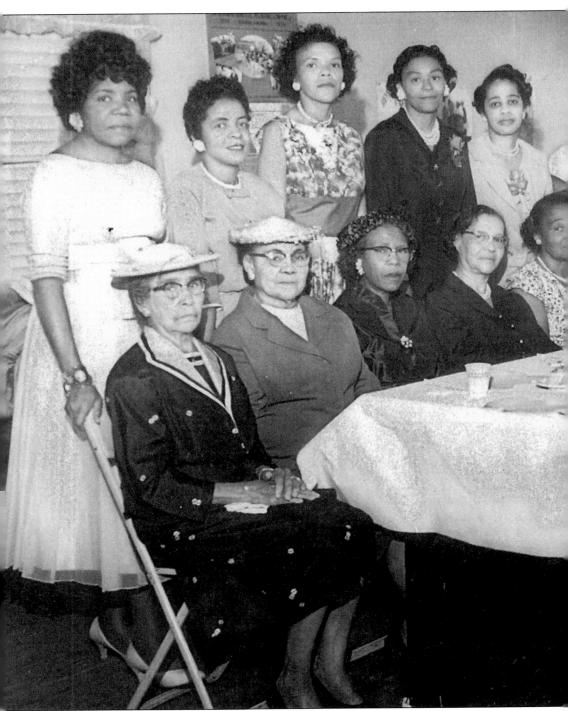

The Chums Club, pictured in the late 1950s at a mother-daughter banquet, was formed in 1936. During the 1930s, Suffolk had very little to offer spirited young people in search of good wholesome fun. At the suggestion of one of their mothers, nine teenage girls organized the club and met weekly to talk, enjoy refreshments, listen to music, and dance. The Chums paid a weekly due of 15¢, which they used for parties. When the girls left

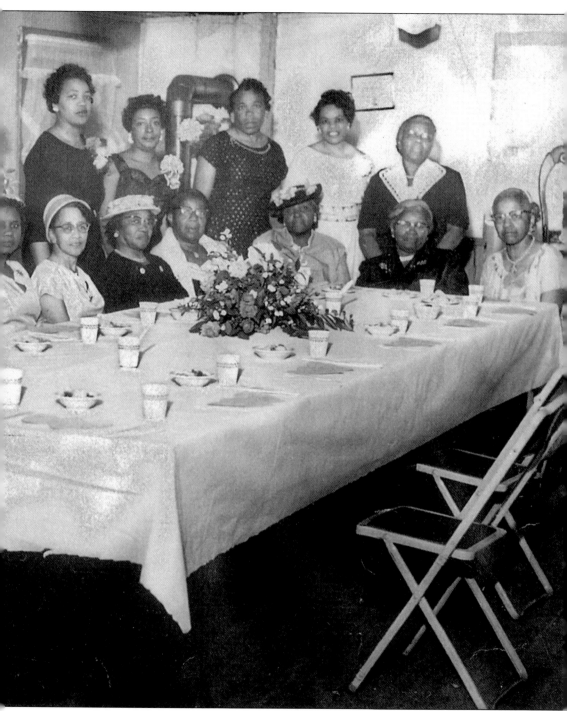

home for college, they met monthly and began serving the community. Living up to their motto—"All Ways Chums, Chums Always"—this group of dedicated women has served the community over the years by sponsoring numerous fund-raisers; they have donated their proceeds to charities and scholarships, as well as other events. The Chums group continues to uphold the values they embraced in 1936. (Courtesy Madelaine Wilson.)

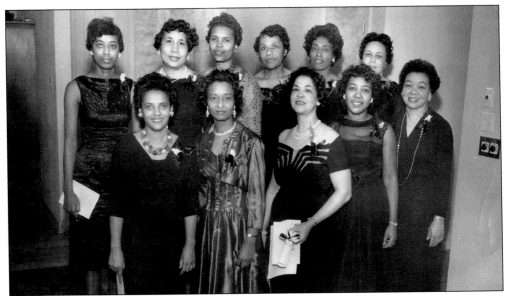

This picture of the Suffolk chapter of the Pinochle Bugs Club, Inc., was taken on the February 3, 1962, during induction services held at the home of Mrs. Jean Hoffler. Dinner followed at the Masonic Hall. Pictured from left to right are (first row) Mrs. Elaine Estes, Mrs. Jean Hoffler (president), Mrs. Thelma H. Pope (vice president), Mrs. Cleo Smith, and Mrs. Rose Hurst (treasurer); (second row) Mrs. Doris Logan, Mrs. Mary A. Davis (corresponding secretary), Mrs. Margaret Moss (secretary), Mrs. Alma Diggs, Mrs. Mary Ellen Ross, and Mrs. Juanita W. Barnes. (Courtesy Mary A. Davis.)

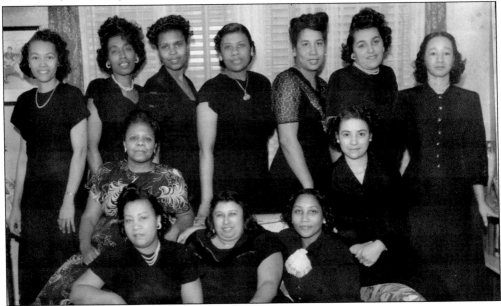

The LaVogue Club was established in 1936. Pictured in 1957 from left to right are (first row) Mrs. Gladys Turner, Mrs. Catherine Harrison, and Mrs. Elaine Waters; (second row) Mrs. Teresa B. Williams and Mrs. Lorraine Finch; (third row) Mrs. Evelyn Chatman, Mrs. Mary Ellen Ross, Mrs. Margaret Moss, Mrs. Alma Diggs, Mrs. Mary A. Davis, Mrs. Dorothy W. Boothe, and Mrs. Mary W. Lawrence. (Courtesy Mary A. Davis.)

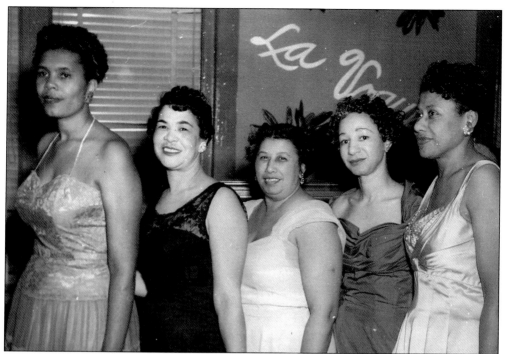

Officers of the LaVogue Club in 1957, from left to right, are Mrs. Margaret Moss, Mrs. Thelma Pope, Mrs. Catherine Harrison, Mrs. Mary W. Lawrence, and Mrs. Alma Diggs. (Courtesy Mary A. Davis.)

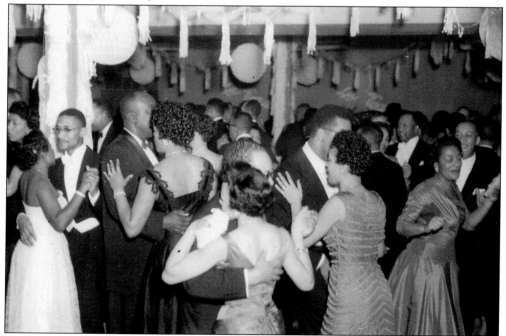

Guests enjoys themselves during a formal dance held at the Union Hall on February 4, 1957. This was one of many black-tie affairs sponsored by the LaVogue Club. (Courtesy Mary A. Davis.)

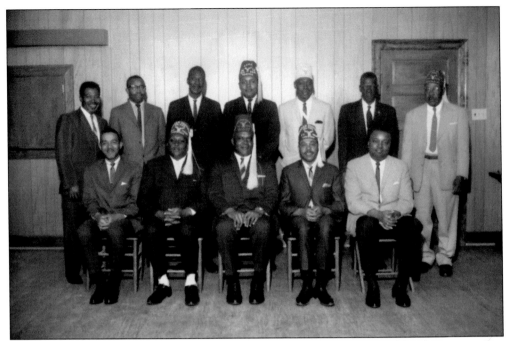

Pictured here are members of the Fraternal Order of Elks in April 1966. Like many other social organizations in the black community, the Elks group has served the community through benevolent programs. (Courtesy The Library of Virginia.)

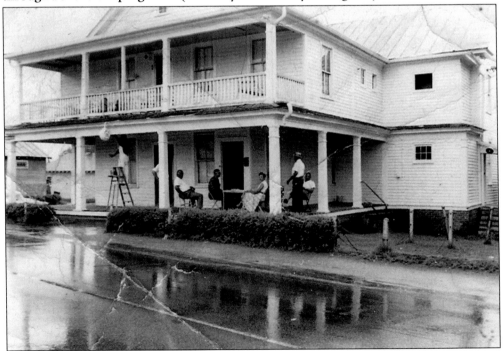

The Elks Home on East Washington Street, pictured here in July 1959, was built in 1921 and was well equipped for the members and friends of the Elks organization. (Courtesy John Riddick.)

Six

HEALTH AND MEDICAL CARE

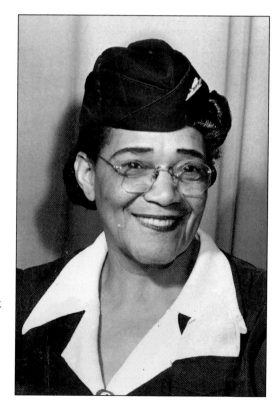

Mrs. Bettie S. Davis was the first black registered nurse to be employed by the Commonwealth of Virginia, the City of Suffolk, and Nansemond County. Born in Murfreesboro, North Carolina, in 1890, Mrs. Davis was well-known throughout the state for her tireless devotion to the education of public health care. She was responsible for organizing school health and preventive programs against typhoid fever and diphtheria. She was affiliated with the Red Cross and various other organizations. Her zest also extended to the church, where she served as a missionary, Sunday school teacher, and a member of the choir and other activities. Mrs. Davis died in 1964, and in 1977, she was honored posthumously for her outstanding work in the city and county for more than 30 years of service. The Bettie S. Davis Village off Carolina Road, containing 60 subsidized apartments for the elderly and handicapped, was named in her honor. (Courtesy Katie L. Bass.)

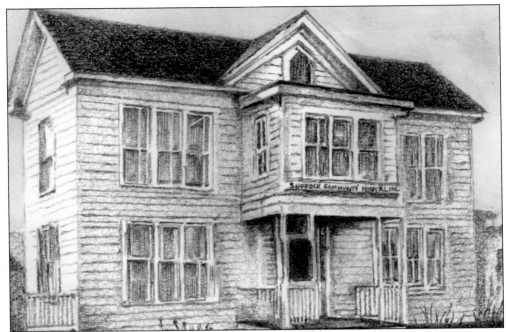

The Suffolk Community Hospital was located on the corner of Madison and Spruce Streets. Dr. William M. Hoffler Sr. and others founded it. The hospital served the black community until it closed in the early 1950s due to lack of funding and the competition it received from the new Louise Obici Hospital, which opened in 1951. (Drawing by Steve Craddock.)

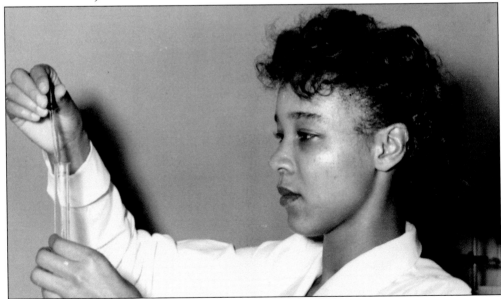

Miss Harlena Colander (MaGee), an X-ray and lab technician at the Suffolk Community Hospital in the mid-1940s. After the hospital closed its doors, Miss Colander went back to school and later received a degree in nursing from the Norfolk division of Virginia State College. She retired from the Hoffler Medical Center on Tyne Street. (Courtesy The Library of Virginia.)

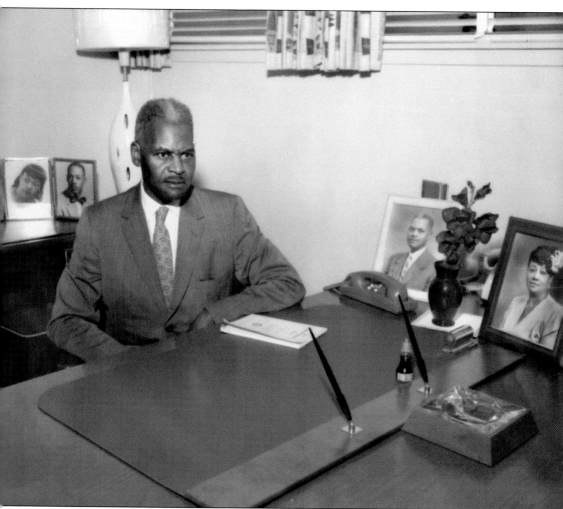

Dr. William M. Hoffler Sr., a physician, moved his family to Suffolk in 1930 from Hagerstown, Maryland, and established his practice. He was a 1920 graduate of Meharry Medical College. While practicing in Hagerstown, he founded the Hoffler Hospital, and he was one of the founders of the Suffolk Community Hospital. In 1959, Dr. Hoffler, along with his sons, Doctors Oswald and William Hoffler, opened the Hoffler Medical Center on Tyne Street. He was a staff member at Louise Obici Hospital. Dr. Hoffler Sr. served on several boards and was affiliated with several organizations including the Omega Psi Phi Fraternity, Inc. After 52 years in practice, he retired in 1973. Dr. Hoffler died in 1979, and in 1984, his home was donated to the First Baptist Church (where he was a member), and it is being used as a convalescent home. (Courtesy The Library of Virginia.)

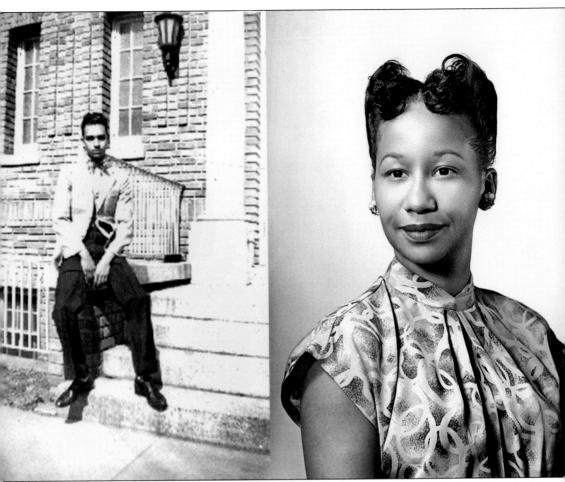

Doctors Lonnie Titus and Margaret Williams Reid were the first husband and wife physicians to practice in Suffolk. "Dr. Margaret," as she was affectionately known, was also the city's first black female physician. Both graduates of Meharry Medical School, they established their practice in 1945. Their countless contributions and donations to the city and Hampton Roads area far exceeded the numerous honors and awards bestowed upon them. Their kindness and generosity are some of the qualities for which they were best known. The Reids provided care to all patients even if they couldn't afford to pay, and they only billed those who could pay. World travelers, educators, and philanthropists, the Reids left Suffolk with a legacy of numerous achievements. (Courtesy Flora W. Chase and The Library of Virginia.)

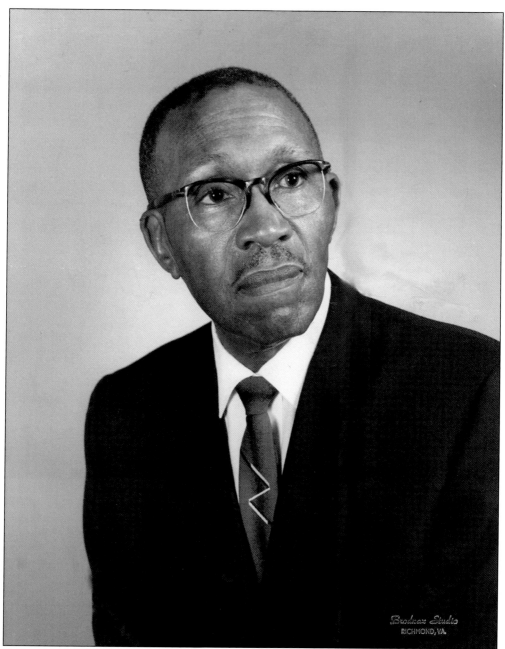

Dr. Harvey M. Diggs Sr., a general practitioner, established his practice in Suffolk in 1935. He was the first black assistant city physician. Dr. Diggs dedicated his life to promoting medical services to the black community, and like other physicians during his time, he cared for people whether they could afford to pay or not. In 1954, he opened the Diggs Professional Building on East Washington Street Fairgrounds, which led to the establishment of the Suffolk Professional Pharmacy. Among his many community endeavors, Dr. Diggs was active in the founding of the Nansemond Credit Union. Pres. John F. Kennedy recognized him in 1963 for his volunteer work in the Selective Service System. (Courtesy Harvey M. Diggs Jr.)

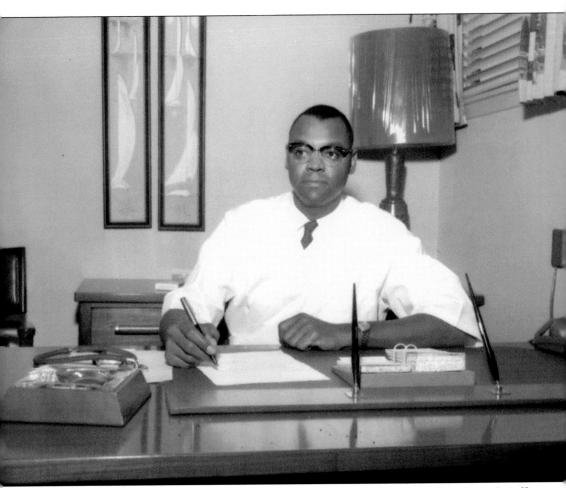

Dr. Oswald W. Hoffler, surgeon was the first black physician to join the surgical staffs at the Children's Hospital of the King's Daughters, DePaul Hospital, and Norfolk General Hospital in 1960. He was also the first black to join the surgical staff at Louise Obici Memorial Hospital. In 1952, Dr. Hoffler began his private practice of surgery at the Suffolk Community Hospital. He served in the U.S. Army as a staff surgeon in the U.S. Army Hospital when he was called to active duty in 1954. A graduate of Howard University College of Medicine, Dr. Hoffler was a member of Omega Psi Phi and Sigma Pi Phi fraternities. Among his other organizational affiliations were the NAACP, Norfolk Medical Society, Old Dominion Medical Society, American Medical Association, and the American College of Surgeons. Dr. Hoffler died in November 2004. (Courtesy The Library of Virginia.)

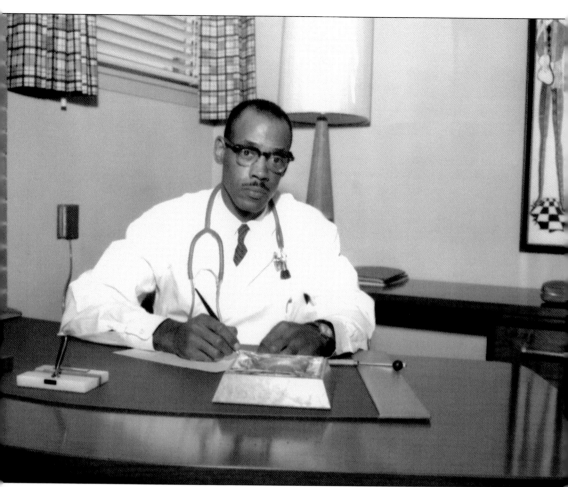

Dr. William M. Hoffler Jr. was well known as an internal medicine specialist. He was born February 1, 1925, in Hagerstown, Maryland. When his family moved to Suffolk in 1930, he began school at Andrew J. Brown Elementary and continued until he graduated from Booker T. Washington High at age 15. Dr. Hoffler received degrees from Lincoln University, Howard University, Meharry Medical College, and the University of Pennsylvania. He was a staff member of Louise Obici Hospital and Norfolk Community Hospital. Dr. Hoffler held memberships in a number of professional and civic organizations, including the National Medical Association, American Medical Association, American Society of Internal Medicine, Omega Psi Phi Fraternity, and the NAACP. He served as past president of the Norfolk Medical Society. He passed away on May 1, 1989. (Courtesy The Library of Virginia.)

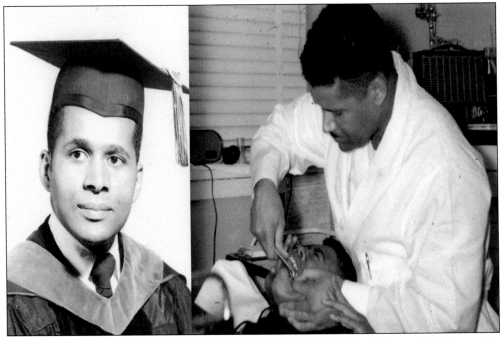

Dr. Edwin Charles Sullivan established his dental practice in Suffolk in 1954 above the Suffolk Professional Pharmacy (Diggs Building). Born in Cambridge, Massachusetts, in 1922, he was a 1953 graduate of Meharry Medical College. In 1970, Dr. Sullivan was appointed to the Suffolk–Nansemond County Consolidation Study Committee, which assessed the feasibility of merging the city of Suffolk and Nansemond County. He was married to Iva M. Reid Sullivan, and they had one daughter, Donna.

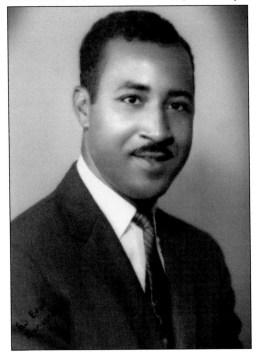

In 1964, Dr. Bernard E. Glover launched his dental practice on East Washington Street. He received his education at East Suffolk High School and went on to receive degrees from Morgan State University and Meharry Medical College. Dr. Glover not only provided a service to the black community, but also he diligently served in the church, acting as a trustee at East End Baptist Church. A U.S. Army veteran, he also served on the Obici Hospital Board of Directors from 1975 to 1989, the Nansemond and Suffolk School Board from 1974 to 1976, and the Nansemond Credit Union Credit Committee. Dr. Glover is a member of the Kappa Alpha Psi Fraternity. (Courtesy Bernard E. Glover.)

Katie Lea Bass worked as a nurse at the Suffolk Community Hospital in the 1940s, and in the 1950s and 1960s, she served as head nurse in Obici Memorial Hospital's "colored" wing. She authored *The Colored Ward*, a book depicting the conditions for black employees and patients at Obici during segregation. (Courtesy Katie L. Bass.)

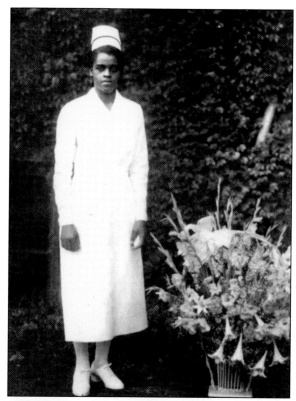

Mrs. Katie Lea Bass, head nurse in the African American ward at Louise Obici Memorial Hospital, is shown giving instructions to Miss Myrtle Green (Rawles). (Courtesy Katie L. Bass.)

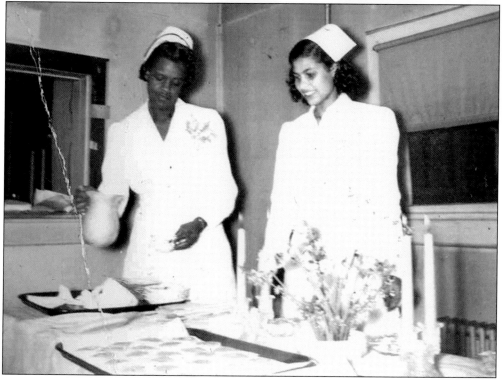

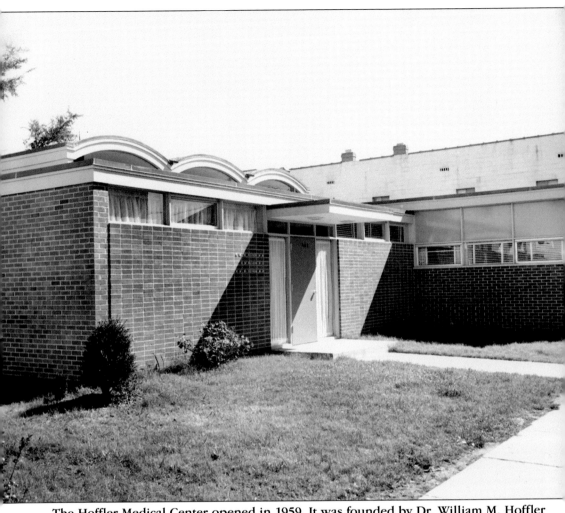

The Hoffler Medical Center opened in 1959. It was founded by Dr. William M. Hoffler Sr., and his sons, Doctors. William M. and Oswald W. Hoffler. It not only served as the physicians' office location, but also as a major medical facility for blacks since the closing of the Suffolk Community Hospital in the early 1950s. (Courtesy The Library of Virginia.)

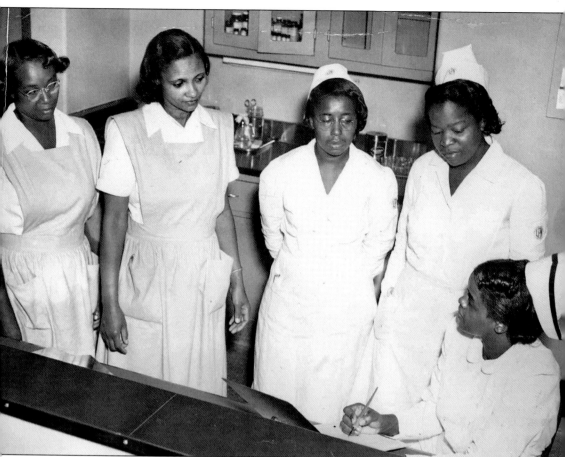

This is a picture of nurses in the colored ward at Louise Obici Hospital. From left to right are two unidentified nurse's aides, Miss Carrie Owens, Miss Frances Powell, and Mrs. Katie Bass, who was head nurse supervisor. (Courtesy Katie L. Bass.)

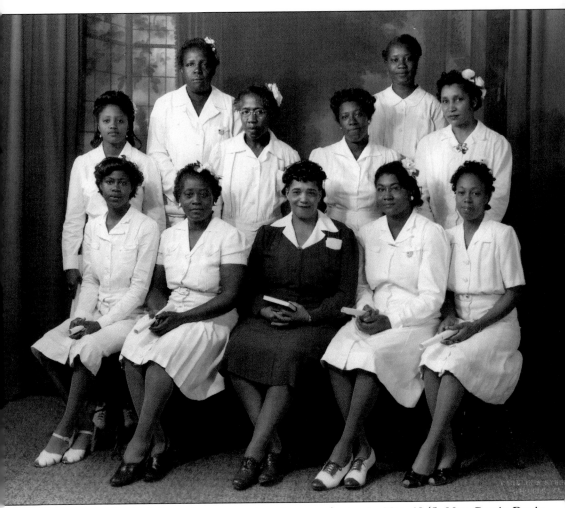

Here are the Red Cross home nursing class graduates in May 1945. Mrs. Bettie Davis, city nurse (front, center), was instructor.

Seven
NOTABLE PEOPLE

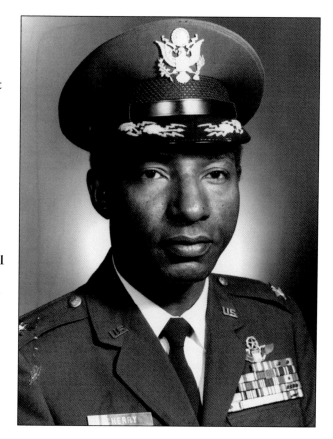

This is Col. Fred V. Cherry, retired U.S. Air Force fighter pilot who served in Korea and Vietnam. Colonel Cherry spent over seven years as a prisoner of war in Hanoi and retired as one of the most distinguished and dedicated veterans of the Vietnam War. He received over 35 medals, including the Air Force Cross, Silver Star, Legion of Merit, Distinguished Flying Cross, Bronze Star with Valor, and two Purple Hearts. In the Arnold Corridor at the Pentagon, a painting of Colonel Cherry was added to the Hall of Heroes. The painting, called "Portrait of a Fighter Pilot" depicts his heroism, character, dedication, and patriotism. Colonel Cherry is now CEO and founder of Cherry Engineering Support Services, Inc., (CESSI) in northern Virginia where he lives. (Courtesy Fred V. Cherry.)

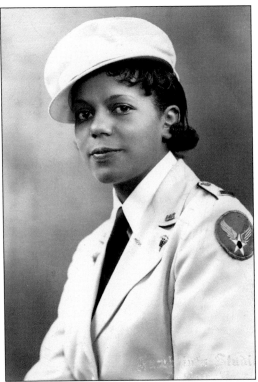

In 1941, Della Raney Jackson became the first black nurse to enter military service during World War II. She is a graduate of Lincoln Hospital School of Nursing in Durham, North Carolina, and reported to duty at Fort Bragg. In 1945, Lieutenant Raney was promoted to captain and headed the nursing staff at the station hospital at Camp Beale in California. (Courtesy Renee Roper Jackson.)

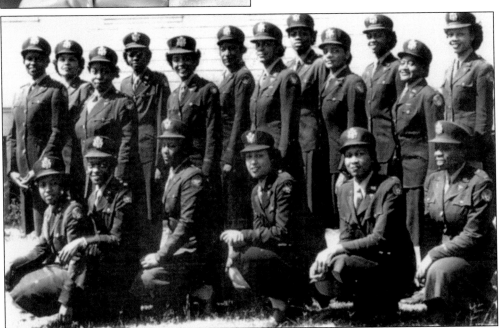

Lt. Della Raney (standing seventh from left) is pictured with nurses stationed at Tuskegee Army Airfield in Alabama. In 1942, Lt. Della Raney was selected as the first African American chief nurse in the Army Nurse Corps while serving at Tuskegee Air Field. Approximately 500 black nurses served in the ANC during World War II. They served in segregated units in the United States and over seas. (Courtesy Grant Williams.)

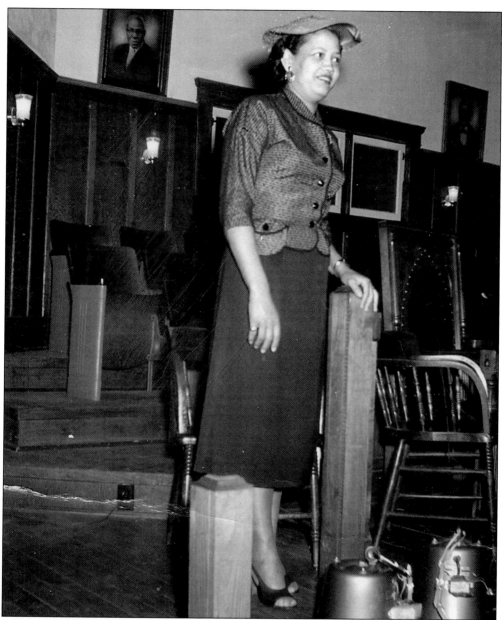

Mrs. Ruby Holland Walden, social and political activist, is the daughter of Axium and Pearl Holland. Mrs. Walden served as president of the Suffolk–Nansemond County chapter of the NAACP and a delegate to the Democratic National Convention. She has served on many boards and committees. Mrs. Walden retired from the STOP (Southeastern Tidewater Opportunity Project, Inc.) organization in 1988. She has worked tirelessly over the years to help make things better in the black community. She was among the group that initiated the Holland Community Center. Mrs. Walden was married to the late Frank L. Walden, a contractor and farmer. From their union, they had four children: Janice, Olin, Sandra, and Pearl. At the age of 83 and still active, Mrs. Walden has become a legend in the black community. One cannot mention the town of Holland without thinking of Mrs. Ruby Holland Walden. (Courtesy Ruby H. Walden.)

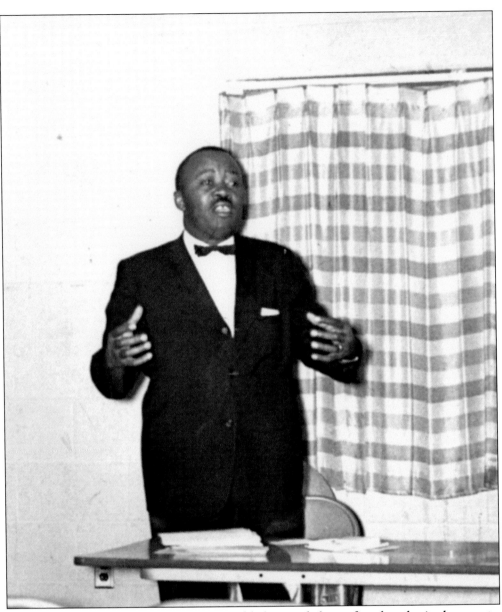

A strong voice in the community, Moses Riddick served almost five decades in the county, city, and state. As a pioneer in politics, Riddick is known to have been responsible for opening the door for many who entered the political arena. The former-vice mayor was the first black delegate from Virginia to attend the Democratic National Convention in 1968 and the first black candidate for Virginia lieutenant governor. In 1946, Mr. Riddick founded the Independent Voters League, an organization to register black voters in Nansemond County. He was instrumental in bringing Dr. Martin Luther King Jr. to speak in Suffolk in 1963. In January 1991, the General Assembly issued a resolution honoring Mr. Riddick for his long distinguished public career in Nansemond County and the city of Suffolk. He received his early education in Suffolk and later graduated from Hampton University. Mr. Riddick died on March 20, 1991, at the age of 74. (Courtesy John Riddick.)

Mr. Mack Benn Jr. was the city's first black superintendent. He served as an educator and administrator in the Suffolk Public School System. He taught at the East Suffolk High from 1953 to 1965 and the John F. Kennedy High School from 1965 to 1970. He was promoted to principal and placed at the Robertson Elementary School in Whaleyville, where he served for two years. Mr. Benn held other positions in the Suffolk School System from 1972 to 1986. He was an active member of the Alpha Iota Graduate Chapter of the Omega Psi Phi Fraternity, Inc. Upon his retirement in 1988, Mr. Benn continued to serve in the community and the school system until his untimely death. (Courtesy Bernice B. Maloney.)

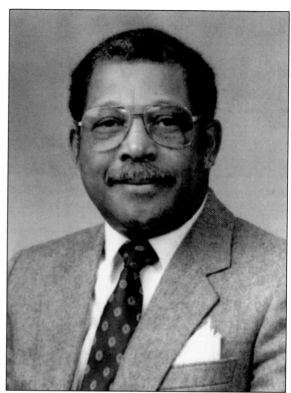

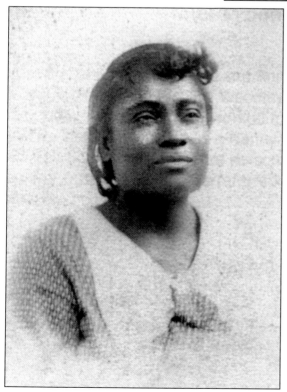

Mrs. Eley Otelia Demiel, Suffolk's oldest-known resident, was known as an inspiration. Born October 30, 1895, she was affectionately referred to as "Miss Eley" and attended Old Savage Crossing Grade School through seventh grade. She was married and widowed twice and out lived one son and 6 of her 10 stepchildren. She was a devout member of the Gethsemane Baptist Church for almost nine decades. She died on July 26, 2004, at the age of 108. In 2001, at 105 years old, Miss Eley was featured in WHRO's century, an eight-part series. (Courtesy Dorothy Demiel.)

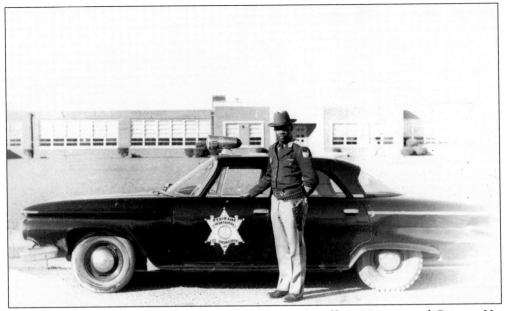

Mr. John Riddick was one of the first black deputy sheriffs in Nansemond County. Mr. Riddick is a graduate of Booker T. Washington High School and serves in the U.S. Air Force. He has been a member of the Suffolk School Board for 16 years and is a member of the First Baptist Church. (Courtesy John Riddick.)

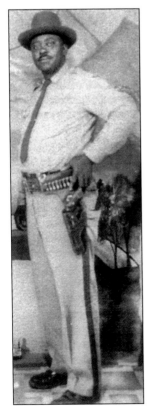

Mr. Junius A. Boone Sr., along with John Riddick, was one of the first black members of the Nansemond County sheriff department in 1960. Through many years of dedication, Sheriff Boone, as he was known, was eventually promoted to chief deputy, and retired as captain in 1984. He was an active member and loyal supporter of the Piney Grove Baptist Church in Buckhorn. (Courtesy Najwa Speight.)

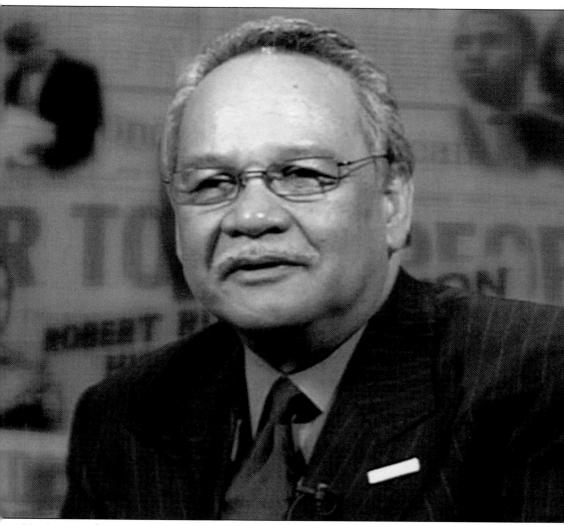

Mr. Raymond H. Boone is founder, editor, and publisher of the *Richmond Free Press* newspaper, the 2003 winner of eight national awards for journalistic excellence from the National Newspaper Publishers Association. The former Saratoga resident is also founder, president, and CEO of Paradigm Communications, Inc. Mr. Boone is the recipient of numerous awards, including the 2003 Dominion Resources Strong Men and Women Excellence in Leadership Award and induction into the Virginia Communications Hall of Fame at Virginia Commonwealth University in 2000. Mr. Boone is a former associate professor of journalism at Howard University. He also worked as a reporter for the Quincy *Patriot-Ledger* in Massachusetts and the *Suffolk News Herald*. A graduate of the Ida V. Easter Graded School and East Suffolk High School, Mr. Boone also holds degrees from Boston University and Howard University.

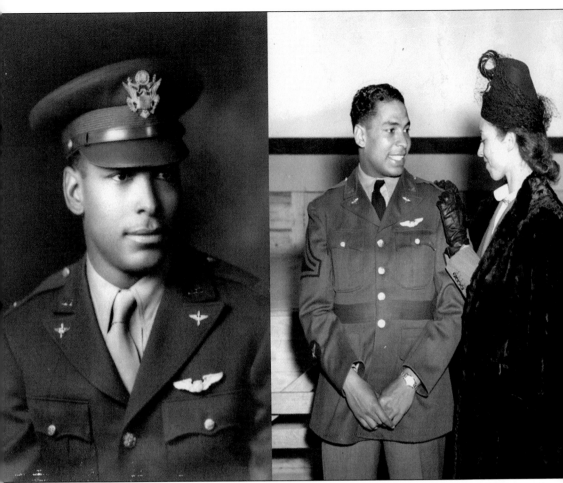

Lt. William Henry "Wild Bill" Walker Jr. was born in 1919 to William H. Walker and Braddie Walker. He was the eldest of eight children. Mr. Walker was a graduate of the Nansemond Collegiate Institute and St. Paul's Polytechnic College. On April 9, 1942, he joined the Army Air Corps and trained at the Tuskegee Army Flying School in Alabama. Upon completion of his training, Mr. Walker was sent to Selfridge Field in Michigan as an officer of the 100th Pursuit Squadron of the 332nd Fighter Group. On October 14, 1943, at the age of 24, he was killed in a midair collision while training in his P39 Air Cobra. Mr. Walker was buried in Oaklawn Cemetery with full military honors. He is pictured at right with his sister, Emma Ruth Walker, after graduating from Tuskegee Army Flying School. (Courtesy Renee Roper Jackson.)

```
CLASS OF SERVICE                                                    1201      SYMBOLS
This is a full-rate         WESTERN                                           DL=Day Letter
Telegram or Cable-                                                            NL=Night Letter
gram unless its de-          UNION                                            LC=Deferred Cable
ferred character is in-
dicated by a suitable                                                         NLT=Cable Night Letter
symbol above or pre-
ceding the address.    A. N. WILLIAMS    NEWCOMB CARLTON    J. C. WILLEVER    Ship Radiogram
                         PRESIDENT      CHAIRMAN OF THE BOARD  FIRST VICE-PRESIDENT
```

The filing time shown in the date line on telegrams and day letters is STANDARD TIME at point of origin. Time of receipt is STANDARD TIME at point of destination

1943 OCT 15 PM 1 09

YA80

JA384 24/23 GOVT=UX SELFRIDGEFIELD MICH 15 1233P

MRS BRADDY K WALKER=

=388 EAST WASHINGTON ST SUFFOLK VIR=

SFG G464 PERIOD REQUEST IMMEDIATE REPLY BY TELEGRAPH COLLECT THE NAME AND ADDRESS TO WHICH YOU DESIRE THE REMAINS OF YOUR SON CONSIGNED=

COLONEL BOYD COAB SELFRIDGE.

SFG G464.

THE COMPANY WILL APPRECIATE SUGGESTIONS FROM ITS PATRONS CONCERNING ITS SERVICE

This Western Union telegram dated October 15, 1943, to Mrs. Braddie Walker asked her where she wanted the remains of her son, Lt. William Henry Walker Jr., sent. (Courtesy Renee Roper Jackson.)

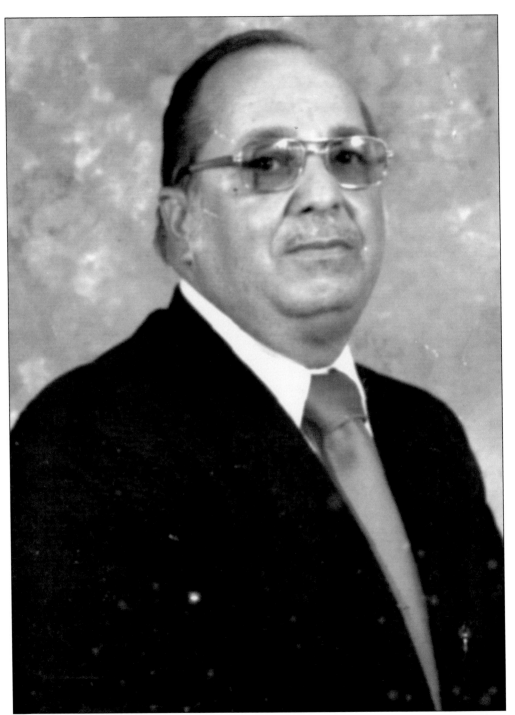

Mr. Melvin Blowe, licensed funeral director, served as manager at Crocker's Funeral Home from the 1960s until 1986. Mr. Blowe was involved in numerous professional, community, and social organizations, including the Virginia Funeral Directors and Embalmers, the Tidewater Fair Association, and the Nansemond Development Company. (Courtesy Jessie Trent.)

Eight
SEPARATE AND UNEQUAL

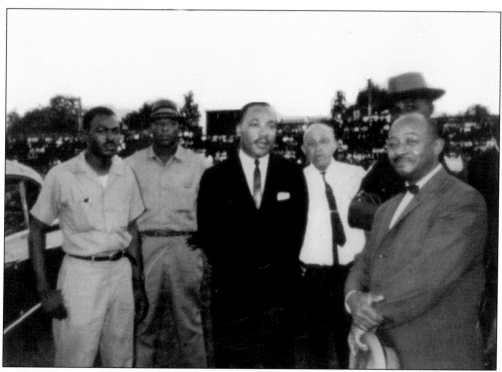

In the summer of 1963, Dr. Martin Luther King Jr. addressed more than 7,500 people at Suffolk's Peanut Park during a "Freedom Rally" of the Virginia Southern Christian Leadership Conference (SCLC). The program was sponsored by the Suffolk–Nansemond County and Isle of Wight Ministerial Alliance, Local Union #26, AFL-CIO, the Suffolk–Nansemond County Chapter of the NAACP, and the Independent Voters League. The primary purpose of the meeting was to raise funds to assist the Virginia SCLC in its effort to register blacks to vote throughout the state. Pictured, from left to right, are Mr. Arlie Taylor, Mr. Nathaniel Walker, Dr. King, Mr. "Punk" Kelley, Deputy John Riddick, and Rev. Maurice Johnson Sr. (Courtesy John Riddick.)

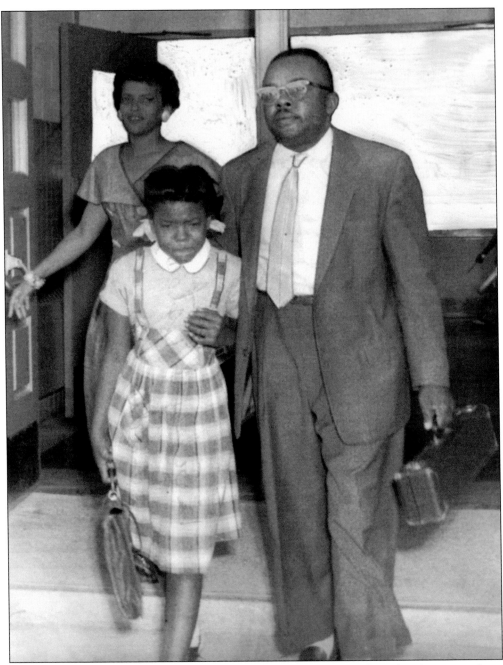

In this photograph, Mr. Sidney Estes and Mrs. Elaine Estes escort their daughter, Lois, from Booker T. Washington High School after being told that she will not be admitted because her father refused to sign a pupil placement form. In 1957, the Estes family initiated a lawsuit in the federal district court in Norfolk, seeking on behalf of their daughter and other rejected students a ruling that the Pupil Placement Act was unconstitutional. Other parents who joined them in the suit were Frank and Ruby Walden, on behalf of their daughter, Sandra; Cecil Wood and his son, Larry; Mr. and Mrs. Lorenzo Peele and their son, Windale; as well as four other parents. (Courtesy *New Journal and Guide*.)

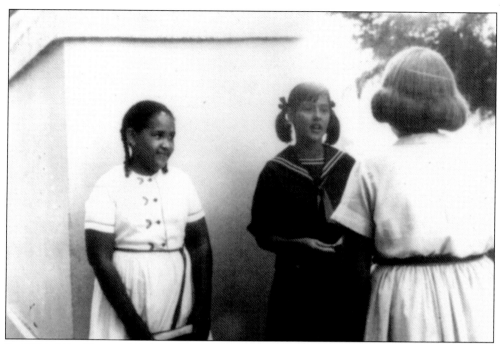

In 1964, Miss Donna Marie Sullivan (pictured left) was one of three girls to integrate the Suffolk Public Schools. Here she stands along with Catherine King (right, back to camera) outside of the Thomas Jefferson Middle School on the day the schools were integrated. (Courtesy Donna A. Sullivan Harper.)

Donna A. Sullivan (Harper), daughter of Dr. and Mrs. Edwin C. Sullivan, was the first and only black valedictorian of Suffolk High School. She went on to earn degrees from Oberlin College and Emory University. Now Dr. Donna Harper, a professor of English at Spelman College has been appointed chairperson of the English Department. She is a nationally renowned scholar who has written and edited books on Langston Hughes. Dr. Sullivan Harper resides in Atlanta, Georgia, with her husband, Thomas J. Harper III, and they have one child, Selena. (Courtesy Donna A. Sullivan Harper.)

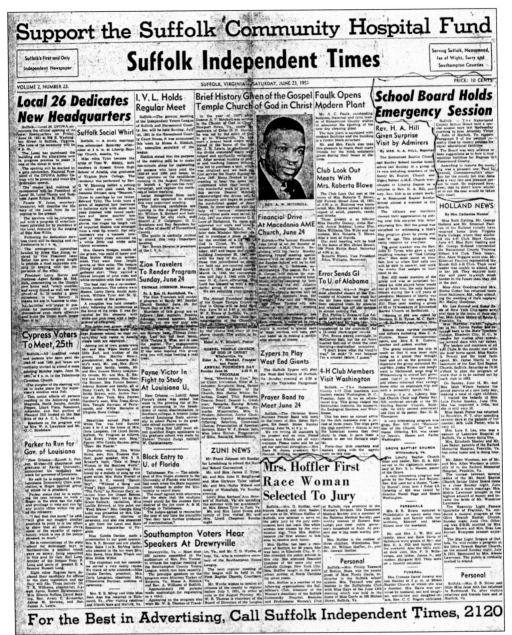

The *Suffolk Independent Times*, June 23, 1951, was Suffolk's first and only independent newspaper. It originated after the white newspaper placed limits on what would be printed in the "colored" section of their paper. The *Independent Times* covered social, political, religious, educational, and personal news of Suffolk blacks. The page was founded and printed by brothers Moses and John Riddick. It also served Nansemond, Isle of Wight, Surry, and Southampton Counties. (Courtesy Ruby H. Walden.)

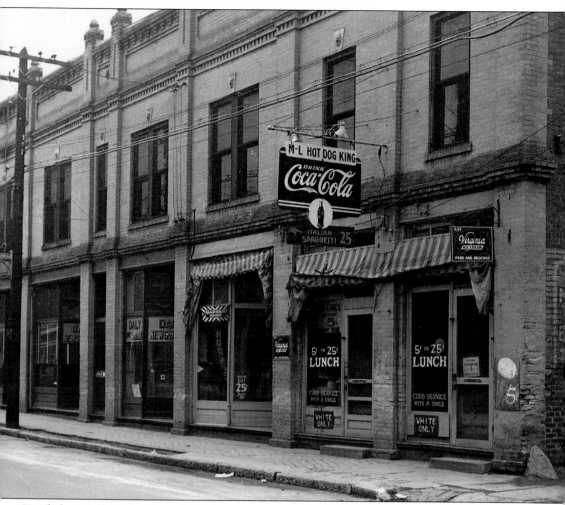

Until the Civil Rights Act of 1964, restaurants like the M. L. Hot Dog King (pictured above) excluded blacks by displaying "white only" signs in front of their businesses. Blacks were excluded from other places of public accommodations including motels and theaters. Noted above the "white only" signs are the words "curb service with a smile." (Courtesy Portsmouth Public Library.)

This is a 1954 tax paid list. Only persons who paid their taxes and whose names were on the list could vote. Blacks had to be current with three years of taxes and in order to be able to vote had to pay $1.50 poll tax. This tax kept many poor blacks from voting. There was a separate list for blacks and whites as shown on this town of Whaleyville list. (Courtesy John Riddick.)

ENDNOTES

[1] "Skeetertown" Kin Folks Still Abound, *The Sun*, March 3, 1991, p. 10–11.
[2] Milton R. Liverman. *A History of Nansemond Collegiate Institute From 1890 to 1939*, dissertation, (1997), p. 1.
[3] Elgin M. Lowe. *Black Churches and Businesses, The Suffolk Area Then and Now*, (1993), p. 63–64.
[4] Ibid., p. 78.